LONG ISLAND
and the
WOMAN SUFFRAGE MOVEMENT

LONG ISLAND *and the* WOMAN SUFFRAGE MOVEMENT

ANTONIA PETRASH

Charleston London

THE
History
PRESS

Published by The History Press
Charleston, SC 29403
www.historypress.net

Cover image: Pin (back) equates patriotism with suffrage. The twelve stars mean that twelve states had passed suffrage at that time, probably 1917, when New York become the twelfth state to grant women full suffrage. *Courtesy of Suffrage First Media Project, author's collection.*

First published 2013

Manufactured in the United States

ISBN 978.1.60949.768.2

Library of Congress CIP data applied for.

CONTENTS

PREFACE

Wait. Wait, they were told.

Work hard. Learn about the political system and how to work within well-established organizations. Nonviolent methods are best, as they do not create hard feelings.

Don't make waves. Don't make enemies. People don't like strident, outspoken women. Have patience. Success will come in due course. Your time will come.

And so they worked and waited. They waited through the long Civil War, supporting African American men and women in their bid for freedom. Surely, once the war was won and the slaves were freed, there would be time for all men and women to be granted equal suffrage.

They endured the long, frustrating years after the Civil War when their dreams were shattered and the freed African American male slaves were granted the vote first. They had worked tirelessly for abolition because they sincerely believed in the cause and because they thought that it would provide the path to equal rights they so desperately wanted.

They wrote books, letters, articles and petitions and published newspapers, leaflets and pamphlets. When they could not afford to publish their own newspapers, they begged for space in others.

They choreographed stunts, rode in wagons, flew in airplanes and teetered on billboards high over the ground. They marched through the wind and the cold, trudged through endless neighborhoods asking for signatures on petitions and made speeches on trains, in drafty auditoriums and on cold and dirty street corners. They were jeered, attacked, jailed, beaten, force-fed and vilified.

And when victory came, it was not because they had waited. It came, in fact, because they finally realized they could wait no longer.

ACKNOWLEDGEMENTS

A book that depends on such intensive research such as this never represents just the work of the author alone; rather, it depends heavily on the assistance of historians, archivists, librarians and like-minded friends who love history and delight in its study and preservation. I am indebted to a host of friends and colleagues without whose assistance and support this book would never have become a reality.

Although I cannot mention them all, special thanks goes to my commissioning editor Whitney Landis, who fielded my panic-stricken e-mails with grace and kindness, and to Dr. Natalie Naylor, the authority on women's history on Long Island, who has been most generous with her continued assistance and support. Thanks also to Arlene Hinkemeyer, who generously shared her files on the suffragists on the East End of Long Island; Suzanne Johnson, director of the Longwood Public Library, who provided me with a wonderful list of suffrage leaders in Suffolk County; and Mark Rothenberg of the Patchogue-Medford Public Library, who shared his files and information on Elizabeth Oakes Smith. I am also grateful to Eleanor Noble and Myrna Sloam and the librarians of the Roslyn-Bryant Library, who helped me research and illustrate the life of Katherine Duer Mackay; Betsy DeMaria of Sagamore Hill National Park Service, for her help with photos of Theodore Roosevelt; Peg Johnston, who generously shared her files, photos and information about Elisabeth Freeman; Assemblyman Charles Lavine and his assistant, Christian Paul, who helped with information about Ida Bunce Sammis; and State

Senator John Flanagan, who shared his father's delightful essay on Ida Bunce Sammis and helped bring her to life.

Kathryn M. Curran and Edward Smith of the Suffolk County Historical Society helped me research and illustrate the life of Rosalie Gardiner Jones; Elspeth Kursh at the Sewall-Belmont House in Washington, D.C., offered assistance with photographs and information; Ronnie Lapinsky-Sax generously shared an image from her wonderful collection of woman suffrage memorabilia; and Elly Shodell of the Port Washington Public Library offered information and contacts about Harriet Burton Laidlaw. Thanks also to Victoria Aspinwall of the Long Island Studies Institute at Hofstra University; Susan Barker of the Sophia Smith Collection at Smith College; Stephanie Gress of the Suffolk County Vanderbilt Museum; and Cheryl Klimaszewski of Bryn Mawr College Special Collections.

I am especially grateful to my wonderful friend Marguerite Kearns, who has generously shared the wonderful stories of her grandmother, Edna, and has offered unstinting encouragement and support. Lastly, I am especially indebted to my own personal circle of inspiration: my friends and colleagues at the Glen Cove Public Library, Director Kathie Flynn and librarian/archivists Carol Stern, Rosa Cella and Jan Angliss; my supportive friends who never tired of asking about the project and commiserating with me about its problems; my sisters, daughters, sons-in-laws and grandsons; and, of course, my wonderful husband, Jack, whose steadfast support and encouragement continues to help me turn my dreams into realities.

INTRODUCTION

We hold these truths to be self-evident; that all men and <u>women</u> are created equal;
that they are endowed by their Creator with certain inalienable rights; that among
these rights are life, liberty and the pursuit of happiness.
 –Declaration of Sentiments, *Seneca Falls, 1848.*

O n a warm July day in 1848 in Waterloo, New York, five quite ordinary
women gathered around a tea table in Jane Hunt's parlor to discuss
their dissatisfaction with women's life in general. Jane was joined by Quakers
Lucretia Mott and her sister, Martha Wright, as well as by neighbors Mary
Ann McClintock and Elizabeth Cady Stanton. While all five were frustrated
by the inequities they faced as women, the most discontented of all was
Elizabeth Cady Stanton, who vehemently poured out her "discontent...with
woman's portion as wife, mother and housekeeper."[1]

Until then, the Stantons lived in Boston, where they enjoyed a satisfying
life filled with rich cultural and social opportunities. Good servants were easy
to find, their children were happy and the family thrived. But in 1847, when
the family moved to Seneca Falls, New York, Elizabeth's life changed. With
her husband frequently away on business, she suddenly found herself isolated
in a rural community with only rambunctious children and disgruntled
servants for company. She began to dream of a better, more rewarding life.

Elizabeth's discontent was infectious. All five women knew the humiliation
of being treated like children, possessing few personal rights or privileges.
In a daring move, they decided to call for a Woman's Rights Convention

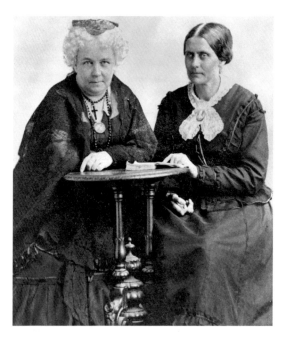

Elizabeth Cady Stanton (left) and Susan B. Anthony. Contrary to popular opinion, the two pioneers did not meet until several years after the Seneca Falls conference. *Courtesy of the National Portrait Gallery, Smithsonian Institution.*

to discuss the "social, civil and religious condition and rights of woman" in the Wesleyan Chapel at Seneca Falls on July 19 and 20.[2]

Such a gathering had never been held before. Those historic two days are considered to be the official beginning of the woman's rights movement, which ultimately resulted in issuance of the famous *Declaration of Sentiments.* Signed by sixty-eight women and thirty-two men, it called for, among other things, the unheard-of right of women to vote. Later, Stanton would join forces with Susan B. Anthony, and the two would spend their entire lives in pursuit of the "final triumph of the right and the true": political equality for all American women.

If the daring women who gathered in Seneca Falls that hot July day in 1848 knew that their battle for equality would take seventy-two long years, one wonders if they might not have climbed back into their wagons and given up right there. After all, they were politically unsophisticated and inexperienced. They had no idea how to organize a major social movement. Many were Quakers, who held a conscientious objection to war and conflict. As women, especially if married, they held very few rights—limited access to education and laws that prohibited them from owning their own property, keeping their own wages or even possessing custody of their own children. They were expected to obey laws they had no voice in making and pay taxes they had no say in spending.

They persevered. It was too late to turn back—too much was at stake. That convention led to others, and the quest for political equality for women begun at Seneca Falls was carried by the human tide of hope and courage

across the state and across the nation, involving the labor of thousands of women and men for many years to come.[3]

Long Island was a long way from Seneca Falls, especially in 1848, when travel was by horse-drawn wagon across rutted roads—close to three hundred miles. There is record of only two people with ties to Long Island attending that first convention: Lucretia Mott and her husband, James Mott, whose family came from Cow Neck, Long Island. (The couple lived in Philadelphia.) One might wonder how much of an impact the women of Long Island could make, given that the island is small in area, about 1,700 square miles, with a population that represented only about 4 percent of the state total.[4] It was then mostly agricultural in nature, far from the capital of Albany and even farther from the middle of the state, where much of the suffrage action was centered. An isolated, fish-shaped arm of land extending into the Atlantic Ocean, it can be reached only by bridge, tunnel or boat.

Despite these limitations, I believe the women who called Long Island home in the nineteenth century and the beginning of the twentieth century were disproportionately responsible for the success of the movement for woman suffrage. But even before that time, Long Island was no stranger to brave women with revolutionary ideas. In 1640, Lady Deborah Dunch Moody came from England in search of religious freedom, founded the community of Gravesend in Brooklyn and was the first woman known to hold a patent in her own name on land in the New World.[5] In 1660, the Wright sisters—Mary, Hannah and Lydia of the town of Oyster Bay and members of the Society of Friends (Quakers)—frequently defied the stricture that forbade women to speak in public by openly lecturing against religious persecution.[6]

During the Revolutionary War, Anna (Nancy) Strong from Strong's Neck near Setauket was an active member of the Culper Spy Ring, which operated on the north shore of Long Island and provided valuable information to George Washington about the placement and activity of the occupying British forces.[7] As we will see in a later chapter, Elizabeth Oakes Smith of Patchogue began lecturing publicly on women's need for equal rights in 1851, becoming the first woman anywhere to lecture regularly on the Lyceum circuit.

Women slowly gathered the courage to speak in public against the evils of slavery (and, later, of alcohol abuse), and these forays helped them hone their skills as lecturers, providing them with their first exposure to the political system. Once abolition was achieved and slavery abolished in 1863, it was a logical step for them to continue to work for equal rights for themselves. From small villages perched on its sandy southern shores, over its mid-island farmlands dug with potatoes and corn, to its rocky north shore, the

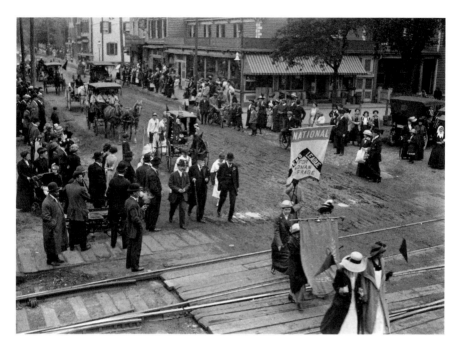

One of the first suffrage parades held on Long Island in Hempstead, 1913. *Courtesy of the Library of Congress.*

movement for equal rights for women found fertile ground on Long Island in which to flourish and grow, and by the end of the nineteenth century, woman suffrage organizations began to dot the organizational landscape.

Some of the participants are well known: Harriot Stanton Blatch, daughter of Elizabeth Cady Stanton; Alva Vanderbilt Belmont, who gave perhaps more than anyone, in terms of dollars and personal commitment to the cause; and Rosalie Gardiner Jones, descendant of one of the first families on Long Island, whose militant and commanding nature inspired followers to dub her the "General." Others were less famous: Harriet Burton Laidlaw, who tried to convince President Theodore Roosevelt to support suffrage, and Katherine Duer Mackay, who founded the Equal Franchise Society and was the first of many wealthy women to become involved.

As the nineteenth century came to a close, the woman suffrage movement began to gain an aura of respectability. Its leaders visited Long Island frequently, lured by the island's bucolic beauty. Elizabeth Cady Stanton and Susan B. Anthony frequently vacationed at the Glen Cove estate of Charles Dana, publisher of the *New York Sun*. In her autobiography, *Eighty Years and More Reminiscences*, Elizabeth recalled spending summers there, as well as with her son, Gerrit, in his home

at Thomaston (near Great Neck) and with her daughter, Harriot Stanton Blatch, at her home in Shoreham.

Wealthy Long Island women such as Helen Deming Sherman Pratt and Louisine Havemeyer devoted time, energy and funding. The benefit of having wealthy women involved in the campaign at first seems obvious—they had the time and the money to write letters, make speeches and join marches. But such an

"Suffrage First" became a rallying cry when the arrival of World War I threatened to derail the movement once again, as it had been derailed during the Civil War. *Courtesy of the Suffrage First Media Project, author's collection.*

assumption possibly belies the truth of the difficulties they, too, might have faced. No one forced them to leave their comfortable lives and homes and expose themselves and their families to ridicule and censure. Husbands and parents were not always sympathetic, and often even wealthy women were financially and socially dependent on both.

At the advent of World War I, women were admonished to give up their campaign for the vote and contribute their efforts to the greater good of winning the war. But the suffragists believed that the democratization of fully half of the nation's population was worth continuing to fight for, despite criticism that it detracted from the war effort. By late 1917, four political parties endorsed woman suffrage,[8] and President Wilson finally gave his approval. New York granted full suffrage to women on November 6, 1917. Three years later, in 1920, the Nineteenth Amendment to the Constitution granted women the vote throughout the nation. The women of Long Island who had toiled so long for woman suffrage could take generous credit for their success.

After 1920, Long Island women continued to take an active role in their communities, both socially and politically. The Nassau County League of Women Voters encouraged women to use their newfound political power to campaign for laws governing child labor and improving public education. Community centers to help immigrants and the poor sprang up across the island. Dr. Verena Morton-Jones founded the Harriet Tubman Community Center in 1928 in Hempstead to serve the needs of local African Americans.[9] The Orchard House was founded in Glen Cove to aid the large community

of immigrants that had settled there to work on the estates.[10] Kate Mason Hofstra donated funds that resulted in the formation of Hofstra University, one of Long Island's first major universities.[11] Additionally, breaking longstanding male barriers, pioneering female pilots literally took to the skies from Long Island, including Elinor Smith, Jackie Cochran and Harriet Quimby, the first woman to earn a pilot's license.[12]

Long Island's suffragists operated a classic grass-roots campaign, and their paths crossed and crossed again. Lucy Burns worked more on the national stage, while Edna Buckman Kearns and Mrs. Thomas L. Manson kept their activities mainly to Long Island. Certainly, the effort was not limited to the women whose lives I have detailed here. There were countless others whose names might not be famous but whose efforts were crucial to the cause. When the older crusaders died, younger ones took their places. The work continued, a river of resolve, labor and devotion flowing from one life, one community and one generation to the next. The work of one was the work of many, and the story of one brings the story of all to life.

As I researched and studied the lives of these remarkable women, I was both honored to write about them and humbled by their accomplishments. Their bravery of spirit and determination should resonate with all of us and encourage us to continue the quest of equality for all men and women throughout the world. We haven't reached that goal yet, and it is vital that we continue the legacy of activism they have left for us.

I have been fascinated by the story of the fight for woman suffrage for many years. My own grandmother could not vote until she was forty-four years old. Yet it seems today that many are unaware of this remarkable story and, worse yet, apathetic about exercising this right that was so valiantly fought for. As Ken Burns and Geoffrey Ward told us in their wonderful book *Not for Ourselves Alone*, Susan B. Anthony phrased it perfectly:

> *We shall someday be heeded, and…everybody will think it was always so, just exactly as many young people think that all the privileges, all the freedom, all the enjoyments which woman now possesses always were hers. They have no idea of how every single inch of ground that she stands upon today has been gained by the hard work of some little handful of women of the past.*

Long Island women, perched on their little slip of land, were without doubt a vital part of that "little handful." While they held no monopoly on these achievements, they made a major contribution very much deserving of our recognition and gratitude.

Chapter 1

ALVA VANDERBILT BELMONT

1853–1933

Demand your suffrage…The world is calling for the great half force, so long and so wrongly ignored, and in this union of man and woman lies a future of a wondrous whole. Just trust in God. She will help you.
—Alva Vanderbilt Belmont

The blue suffrage flag, with its four white stars, fluttered gaily in the breeze that warm August afternoon in 1909 in Newport, Rhode Island. There was excitement in the air as six hundred people, mostly women, descended on Marble House, the opulent stone palace built by Alva Vanderbilt Belmont and her first husband, William K. Vanderbilt. Some purchased one-dollar tickets that allowed them to hear such illustrious speakers as Anna Howard Shaw and Julia Ward Howe, while others held tight to their five-dollar tickets that admitted them on a house tour, up the majestic yellow marble staircase and through the rooms of the impressive Beaux Arts mansion.

But not everyone felt that the suffrage rally held in the summer colony of Newport was a good idea. There were murmurings among the other residents that Alva's suffrage meetings had brought too much undesired publicity for Newport. As photographers roamed through the crowds, snapping photos, some of Alva's disapproving neighbors (who nonetheless couldn't resist attending) turned their backs to avoid being photographed—to avoid such obvious evidence of their hypocrisy.[13]

Alva cared little what these women thought. She had opened her home and her heart to a cause in which she fervently believed, spending thousands of

Alva Vanderbilt Belmont. *Courtesy of the Library of Congress.*

dollars of her own money. Benefits realized from her open house that day for the woman suffrage movement would be impressive, both in funds and publicity, and even some staunch Newport residents were convinced by the speeches to embrace the suffrage cause. But Alva did want to keep the goodwill of the summer community, so she promised her Newport friends that she would invite them to a luncheon where no mention of suffrage would be spoken.

She kept her word. But as the women sat down to the delicious lunch, Alva's message was still heard loud and clear, for rimming the lovely white porcelain dishes in blue script was the eloquent but silent plea: "Votes for Women."[14] The women got the message, whether they wanted it or not.

Alva Vanderbilt Belmont was unarguably the most outspoken and controversial advocate for woman suffrage that Long Island had ever seen. She was immensely wealthy, and her wealth imbued her with an unmitigated desire to have her own way, no matter the cost. Some liked her. Most respected her. Many loathed and avoided her at all cost. But despite some unpleasant character flaws, Alva Vanderbilt Belmont was fearless and loyal. If she was blunt and insulting, well, that was just too bad. She was not afraid to spend enormous sums of her own money to right what she considered an egregious wrong to all women—denial of the right to vote.

Alva Erskine Smith was born on January 17, 1853, in Mobile, Alabama, seventh of nine children of cotton merchant Murray Forbes Smith and his wife, Phoebe Ann Desha. (Only five children survived.) The family was prosperous though not wealthy. Her father was descended from the Stirling family of Scotland. Her mother was the daughter of Tennessee congressman Robert Desha. A few years before the Civil War, the family moved to New

York, where they entered briefly into New York society, and then to Europe, where Murray found work in England and Phoebe took the children to live in France.[15]

By her own admission, Alva was a difficult child, combative and determined to have her own way from an early age, a "born dictator." Like many men of the time, her father prized sons, feeling that the family was better represented by them rather than by its daughters. Alva's deep resentment of her father's preference for her brothers might account, at least in part, for her lifelong determination to prove herself right and equal at all costs.

Alva blossomed in the three years she spent in France. She studied in a French boarding school and became entranced with all things French. In 1869, when her father decided that the family must return to live in New York, Alva was heartbroken. She loved the French language, culture and art and, at the age of sixteen, was afraid of the challenges she would face reentering New York society.

Acceptance into New York society would prove difficult for the Smiths, having been away for four years. In 1871, Phoebe Smith died, and Alva was distraught, feeling that she had lost the only person who had ever really understood her. Her father's business dealings went into decline, and after two years of flirting with "genteel poverty," Alva decided that the only way to rescue her family from penury was to marry and marry well. A childhood friend, Consuelo Yznaga, introduced her to the wealthy William K. Vanderbilt, grandson of Cornelius Vanderbilt, the American industrialist who had made his fortune in shipping and railroads and who was reported to be the wealthiest man in America. In 1875, Alva and William K. Vanderbilt were married. Alva was twenty-two years old.[16]

With her newly found fortune and her new husband's approval, Alva began a building program designed to dazzle New York society. She hired architect Richard Morris Hunt to build her a $3 million chateau on Fifth Avenue, a $2 million Newport Rhode Island "cottage," Marble House, and a one-hundred-room mansion in Oakdale, Long Island, called Idlehour (now home to Dowling College). The couple had three children: Consuela, born in 1877; William Kissam Jr., born in 1878; and Harold Stirling, born in 1884.[17]

Despite their enormous wealth, Alva never felt completely comfortable with their position in New York society. Certain that having English nobility in the family would solidify that tenuous position, she determined to marry their daughter, Consuela, to a member of the English royalty, despite the fact that the young woman was in love with someone else. In November

1895, she virtually forced Consuela to marry Charles Richard John Spencer-Churchill, the ninth duke of Marlborough, thus condemning her daughter to an unhappy marriage thousands of miles away in England. (In later years, when Consuela was attempting to obtain an annulment, Alva would finally confess that she had forced the girl into the marriage.)

Alva and William K.'s own marriage was not a happy one; they divorced in 1895, a few months before Consuela's wedding. It was one of the first divorces of their social class. Alva received an enormous settlement—close to $2.3 million dollars, an income of $100,000 per year, the deed to Marble House and sole custody of their three children.[18]

On January 11, 1896, she married Oliver Hazard Perry Belmont, son of a wealthy banker and grandson of Commodore Matthew Calbraith Perry, who had commanded the naval expedition that opened U.S. diplomatic relations with Japan in 1854. At his father's death in 1890, Oliver's inheritance was rumored to be $60 million.[19] In 1897, Alva again turned to her architect friend Richard Morris Hunt to build them a mansion in East Meadow, Long Island, which they called Brookholt. But Alva's newly found marital happiness was not to last; Oliver died suddenly of complications from an appendectomy in 1908, leaving her his entire fortune.

For the first time in her life, Alva was completely alone. Her children were grown and no longer needed her. She was financially one of the richest women in America but felt bereft and depressed. Her daughter's marriage was already over, as was the marriage of her son Willie K., and she was facing a life of useless loneliness. But fortunately for the then-struggling woman suffrage movement, all that was about to change.

In March 1909, another Long Island socialite, Katherine Duer Mackay—who had been a bridesmaid at Consuela's wedding—invited Alva to her home in Roslyn to listen to a lecture by Ida Husted Harper, author of the *History of Woman Suffrage* and *The Life and Work of Susan B. Anthony.* Harper expressed concern that the movement was suffering from inertia; indeed, no state had granted women the vote since Idaho in 1896, and the last debate on woman suffrage in the U.S. Senate had been heard in 1887.

The National American Woman Suffrage Association (NAWSA) seemed gripped by the same lethargy. Its headquarters were in Warren, Ohio, far away from the center of the mainstream public media in New York. Disdainful of the militant tactics of British suffragettes, NAWSA continued a campaign of polite yet placid activism, ignoring the pleas of younger, more enthusiastic suffragists like Alice Paul and Lucy Burns. Later that month, Alva invited NAWSA president Anna Howard Shaw to dinner, and the two

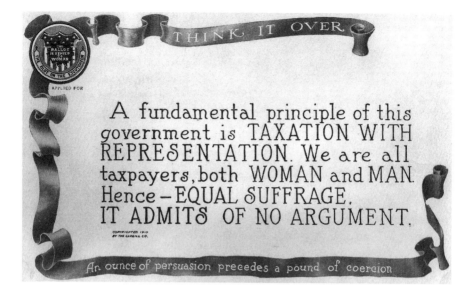

Postcards were frequently used to communicate persuasive messages for or against suffrage. NAWSA published this series in 1910 to counteract those of the anti-suffrage movement. *Courtesy of the Suffrage First Media Project, author's collection.*

discussed suffrage until early the next morning. Alva decided that she had found a cause that she could believe in. She joined as a lifetime member of NAWSA and began working immediately in the cause of woman suffrage.

Characteristically, Alva jumped into the movement with full force. With her own money, she purchased a building at 505 Fifth Avenue and convinced NAWSA to move its headquarters there from Warren, Ohio, offering offices to both NAWSA and the New York State suffrage organization. Sensing the importance of publicity, she established and funded a press bureau in the building to take advantage of New York's central location of the nation's most influential newspapers and magazines.

She established her own organization, the Political Equality Association (PEA), and proclaimed herself president. The PEA rented eleven sites throughout New York City where young workingwomen there could learn about suffrage by attending lectures and joining discussion groups. In a controversial move that angered many of the old guard suffragists, she also established a center in Harlem to offer the same amenities to African American women who might feel excluded from the mainstream movement.[20]

The rally at Marble House in Newport in August 1909 solidified her position as a moving force in the suffrage movement. However, as usual, Alva's participation, even all her hard work, engendered controversy. The older

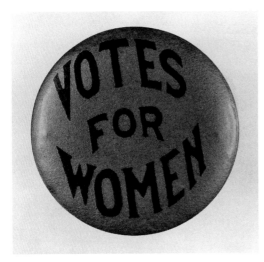

This small "Votes for Women" button is much like the ones Alva distributed to the factory girls. *Courtesy of the Suffrage First Media Project, author's collection.*

members of NAWSA who had toiled diligently for years resented her sudden intrusion into their world, funding impressive lectures and luncheons, opening suffrage "centers" and spreading her cash and influence around in a most "unseemly" manner. It did not help that she always considered herself to be right and seldom took anyone else's opinion into account. She was accused of engineering a feud between herself and the well-liked Katherine Duer Mackay. Unfortunately, her powerful personality could be both an advantage and a hindrance to the cause she wanted so desperately to advance.

Even before her interest in suffrage, Alva had supported philanthropic causes, funding the Hempstead Hospital in Hempstead Long Island and building and supporting the Sea Side Hospital for sick children in Great River, Long Island. An additional cause that interested her was the plight of the young girls who toiled many hours for low wages in New York's garment industry. Alva firmly believed that "such things would not happen if women had the vote" and boldly sent suffrage buttons to be distributed to shirtwaist factory union members.

In November 1909, a general strike of the garment workers in the shirtwaist factories was called, one of the largest political demonstrations ever staged by New York's workingwomen. Alva immediately implored her wealthy friends to back the strikers and, with her usual flamboyance, rented the massive Hippodrome amphitheater in New York City for a meeting on December 6. The *New York Times* reported that eight thousand people attended, and many were turned away.

Although it was billed as a rally in support of the working girls' strike, it was decidedly pro-suffrage in tone. Massive blue flags were hung on both side walls carrying the message "Votes for Women" in white lettering, while banners that hung from the ceiling told the rest of the story: "We Demand Equal Pay for Equal Work" and "Give Women the Protection of the Vote."

Speaker Anna Howard Shaw assured the strikers, "Your cause is our cause, and our cause is your cause." When Alva heard that some of the strikers were being arrested and jailed, she went down to the city night court and was available to bail out anyone who needed help so the young girls wouldn't have to spend the night in jail. Alva could be demanding and autocratic, but she was not afraid to stand up for her beliefs, even if it was personally inconvenient for her, and such personal commitment won her much approval with the union members.

In addition to coordinating rallies and meetings, Alva wrote a prodigious number of articles in support of suffrage. In her article "Woman's Right to Govern Herself," published in the November 1909 issue of the *North American Review*, she pled eloquently:

> *Sisters, I ask you to put behind you these fallacies of the past; discard vain dreams; rely upon yourselves; have valiant aims believing that your rights are the same as those of man...Believe that Motherhood should be no greater than Fatherhood, that the wife should not be the unpaid servant of the husband, but both must be equal. Full of courage, with faith in yourself, go forth as an equal in the race.*

By 1912, Alva was ready to join her voice with those who believed that the American woman suffrage movement needed more militant activities to achieve its goal. On a visit to daughter Consuela (herself an ardent suffragette, with whom Alva had finally reconciled) in England, she became acquainted with Emmeline Pankhurst and her daughters, and although she did not entirely approve of their militant tactics, she was convinced that the time had come to change to a more active course. In 1913, to the dismay of NAWSA leaders, she invited Emmeline Pankhurst to visit the United States and sponsored Ms. Pankhurst on a speaking tour.

While Alva was trying to convince NAWSA to change its course and become more politically dynamic, a young Quaker woman, Alice Paul, was trying to do the same. Instead of attempting to achieve suffrage on a state-by-state basis, Paul believed that the only sensible course should be to concentrate efforts on the passage of an amendment to the U.S. Constitution. She convinced reluctant NAWSA leaders to allow her and fellow activist Lucy Burns to establish the NAWSA-sponsored Congressional Union for Woman Suffrage (CU) and to appoint her the chair.

When Alva heard of Alice Paul's work, she was immediately interested. The two met in January 1914 and at once sensed in each other a kindred

spirit. Like Alva, Alice Paul was single-minded, relentless in the pursuit of what she considered right and dictatorial in her methods. She wasted little time on pleasantries (to the point of rudeness) and was impatient with those whose time might be claimed by family duties. She and Lucy Burns had both spent time in English prisons, where they had been beaten and force-fed; they were tired of the slow tactics of NAWSA and insisted on a more forceful campaign. Finally, Alva had found someone whose powerful nature met her own and whose work she could wholeheartedly support. When Alva's attempt at convincing NAWSA to relocate its national headquarters to Washington, D.C., was rejected, she finally broke ties with that organization and switched the allegiance of the PEA to the fledgling CU. The CU formally merged with the Woman's Party on March 2, 1917.[21]

In the summer of 1914, Alva reprised her rally at Marble House in Newport, staging another huge open house that again attracted thousands of supporters and featured Consuela as a speaker. But it would be the last great rally in Newport; in 1917, she built a new home on Long Island Sound

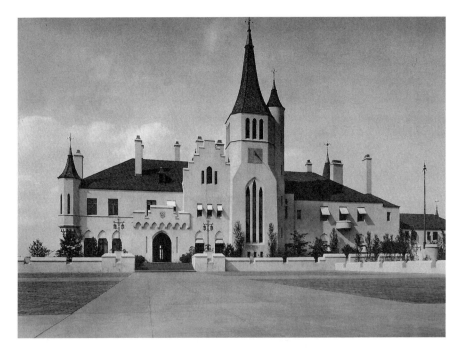

Alva Vanderbilt Belmont's French Renaissance–style estate, Beacon Towers, built in 1917–18 on Sands Light Road in Sands Point. The estate was the site of the 1920 National Woman's Party Conference. *Courtesy of the Suffolk County Vanderbilt Museum, Centerport, New York.*

in Sands Point that she named Beacon Towers, and in the future, it would be to this home that she would welcome fellow suffrage workers and conduct fundraisers and meetings.

In January 1917, when Alice Paul and the NWP began picketing the White House, Alva was delighted that some forceful action was finally being initiated and immediately sent a check for $5,000. During the first few months, the pickets attracted mild if amused attention from the public and President Wilson, who would smile and wave at them as he passed in and out of the White House gates. Later that year, after the United States had declared war against Germany, the situation turned ugly. The pickets were arrested, accused of treasonous behavior, imprisoned and subjected to degradation and torture.[22]

Although Alva never physically joined the pickets, she supported them in every way she could, providing funds, circulating petitions and bringing pressure on members of Congress to pass the Susan B. Anthony Amendment. She agreed with Alice Paul that the Democratic Party should be held responsible for failure to pass the amendment since it was the party in power. Finally, after seventy years of campaigning, the House of Representatives passed the amendment on January 10, 1918, by a vote of 274 to 136 (with 17 not voting). After two failed attempts on June 4, 1919, the Senate passed the amendment by a vote of 56 to 25. Fifteen months later, on August 26, 1920, the amendment was finally ratified by the necessary thirty-six states, and woman suffrage became the law of the land.[23]

In 1921, Alva was elected president of the NWP, a position she would hold for the rest of her life. Using $146,000 of her own funds, she purchased a house in Washington, D.C., for its headquarters. In 1927, when the government needed the property for the construction of the new Supreme Court Building, Alva used the funds from the sale to purchase a mansion across the street on Constitution Avenue, which is now the Sewall-Belmont House Museum.[24]

Her friendship with Alice Paul continued. The young Quaker woman would often stay with her at Beacon Towers, and the two would discuss the possibility of establishing a separate woman's political party. Both agreed that the fight for women's equality was just beginning. Alice Paul would spend the rest of her life advocating for the Equal Rights Amendment, and Alva would continue to lobby for women's equality for the rest of her life as well. Alva spent much of that time in France, where she had been so happy as a young girl. She died there in 1933 and is buried next to Oliver in Woodlawn Cemetery in Queens, New York. Typical of Alva, she left strict

instructions regarding her funeral. There were only female pallbearers, and her coffin was draped with a banner proclaiming Susan B. Anthony's motto, "Failure is impossible."[25]

No one would dispute the claim that Alva Vanderbilt Belmont was a polarizing figure whose indomitable will and resolute spirit would not be tamed. She began fighting as a child against what she considered to be her father's unfair preference for his sons over his daughters. She continued battling to assume what she considered was her family's rightful place in society, and she later brought that fighting spirit to the battle for woman suffrage. Along the way, she made enemies. Carrie Chapman Catt of NAWSA refused to acknowledge her contribution to the suffrage cause, and even her good friend Alice Paul sometimes downplayed Alva's role. But she could also be witty and charming and displayed enormous energy. She was the first wealthy woman to donate so much of her own fortune to the cause of woman suffrage. It is doubtful that the NWP would have achieved such success without her prodigious support and hard work.

On her forty-ninth birthday, Oliver Belmont presented Alva with a statue of Joan of Arc, whose fiery, determined personality Alva had always admired and identified with. Perhaps this connection wasn't too far off the mark. Both were ahead of their time, both were determined and strong-willed and both made lasting impressions on society that the world would not soon forget.

Chapter 2

HARRIOT STANTON BLATCH

1856–1940

Women, it rests with us.

—Harriot Stanton Blatch

The atmosphere in the Tenafly, New Jersey house that cold March day in 1882 was rife with tension and thinly veiled resentment. A mother was ill from overwork. A daughter had been called home suddenly from a European tour. A close friend was being uncooperative and divisive. Old rivalries were roiling. And a publisher was waiting impatiently in the wings.

To an uninformed observer, this scenario might not seem unusual. Aren't there resentments and rivalries in all families? But this was the home of the leader of the woman suffrage movement in the United States, Elizabeth Cady Stanton. She had undertaken the monumental task of writing the *History of Woman Suffrage* with her colleague, Susan B. Anthony, and was working on the second volume. Anthony was away attending meetings and conventions and had left the major responsibility to Elizabeth, who was suddenly felled by illness. Help was desperately needed.

Elizabeth's daughter, Harriot, was on a tour of Europe, enjoying a respite from family duties, and was in no hurry to come home. But when she arrived, she found her mother so ill that she was filled with concern, as well as just a bit of resentment that Susan B. Anthony had left her friend to soldier on alone.

Yet another controversy complicated matters. Since its inception in 1848, the woman suffrage movement had been fraught with dissension over differing theories, and in the late 1860s, it finally split into two competing

Harriot Stanton Blatch. *Courtesy of Bryn Mawr College Special Collections.*

factions: the American Woman Suffrage Association (AWSA), led by Lucy Stone and Henry Blackwell, and the National Woman Suffrage Association (NWSA), led by Stanton and Anthony. Stanton and Anthony were stubbornly reluctant to include AWSA in the history, while AWSA was equally reluctant to allow itself to be included. Into this fray stepped a voice of youthful reason. How could you write a true history of the movement, Harriot argued, if both sides were not included? In her autobiography, *Challenging Years,* she recalled reasoning with the two stalwarts: "I contended that since the two associations were and had been in an internecine war it would certainly do credit to the authors if they rose above the roar of battle and gave space for a record of the work of their antagonists."

Stanton and Anthony reluctantly agreed. And as her reward for mediating this compelling drama, Harriot was given the formidable task of writing the chapter herself, a "dog's life" for which she received $100 and no credit, save the gratitude of all concerned.[26]

Such dedicated work in the service of her mother's fight for woman suffrage was typical of Harriot Stanton Blatch. While she may have occasionally chafed at a life shadowed by a famous mother, even showing flashes of resentment at being taken for granted, there was never any real doubt where her true loyalties lay. She had taken up the mantle of the suffrage cause early in life, and over the course of her life, it undoubtedly became her own. But she approached it on her own terms, bringing to bear the significance of her own unique place in time that was quite different from her mother's. After all, in 1882, the status of women had changed dramatically since 1848, when her mother daringly called the first woman's rights convention in Seneca Falls, New York. Women were now represented in numerous professions; many were financially independent, and even married women could claim

more rights and privileges than ever before. Except, of course, for the most elusive right of all—the right to vote. That, they would discover, was a battle they would have to ultimately win for themselves.

Harriot was born on January 20, 1856, in Seneca Falls, New York, sixth child and second daughter of Elizabeth Cady and Henry Brewster Stanton.[27] The Stanton home was lively and boisterous, but with both parents intensely involved with the politics and issues of the day, the children were not always the focus of their lives. Henry was a journalist and popular speaker for the abolition movement who was often away from home. Elizabeth was the founder of the woman suffrage movement, a caring, loving mother who was nonetheless torn between devotion to her family and to the movement she herself had begun. "My mother longed to be done playing the part of satellite of the dinner-pot and cradle," Harriot remarked in *Challenging Years*. "Not as another baby, then, was I welcome, but as a girl, their hearts rejoiced over me."[28]

With her husband frequently away on business, Elizabeth depended on her mother and sisters to help her with the children. Harriot and her sister, Margaret, spent summers at the Cady home in Johnstown, New York. The Stanton children sometimes resented their Aunt Susan (Susan B. Anthony) since it was she who invariably called their mother away to work with her on the suffrage cause. Harriot once recalled that for all of her life "I still attach to the whistle of an engine heard in the distance the thought 'Mother is going away.'"[29]

In contrast to her home in Seneca Falls, where there were five brothers and a father, the house in Johnstown was the exclusive enclave of women—her grandmother, her two aunts, her sister and herself—and it was there that Harriot learned firsthand the potential power of women. At Grandmother Cady's house, women controlled and cared for everything themselves. In Johnstown, she learned to read and was given the important task of reading the daily newspaper aloud to Grandmother and the aunts. Using this simple educational tactic, the aunts saw to it that she improved her reading skills while she learned about the important happenings of the day: Lincoln's inauguration, the secession of the Southern states and the beginning of the Civil War. The rule of the house at Johnstown, as at her home in Seneca Falls, was freedom of speech. She was encouraged to think for herself and to form and voice her own opinions. No one was a bit surprised, therefore, when Harriot found the courage to change the spelling of her first name to be different from that of the Aunt Harriet for whom she was named.

In 1868, the Stantons moved to Tenafly, New Jersey, where Harriot and her siblings attended local schools. Elizabeth was determined that all her

children attend college and planned for Harriot to attend coeducational Cornell University. But Harriot's Aunt Harriet was financing her education and preferred her namesake attend the new all-woman Vassar College, and so both mother and daughter's ideals of freedom of decision were trumped by monetary concerns. Harriot reluctantly attended Vassar and later came to appreciate the education she received there, including the privilege of studying with Maria Mitchell, the first woman to achieve success as an astronomer. She graduated with honors in 1878.

After a year studying at the Boston School of Oratory, Harriot planned to embark on a career traveling and speaking on women's rights with her mother. Whether this was her idea or Elizabeth's it's hard to discern, but after a dismal first season as an orator, Harriot suddenly changed her mind and accepted the position as a tutor and companion to two young girls who were traveling to Germany. Perhaps she needed simply to get away from her mother's close scrutiny. Surprisingly, Elizabeth openly supported her decision, surmising that she would be away two or three years, reading and studying, and would return to take up her career helping promote woman suffrage.

The freedom and adventures of travel in Europe suited Harriot, and she made many friends there. She and her charges swept through Germany enjoying an active social life of dances and "mixed sex" entertainments.[30] She attended her brother Theodore's wedding in Paris in the spring of 1881. But all was not perfect. She was denied entrance to the École Libre des Sciences Politiques in Paris because of her sex, a major disappointment. Then, at the beginning of 1882, she received the sudden summons to cancel her travels and return home.

But the aborted trip had a silver lining in the form of a "tall, dark Englishman" named William Henry Blatch (Harry to his friends), a businessman whom she met on board ship returning home. Harry was coming to the United States on business for his father. The two were instantly drawn to each other. They were married later that year and settled in Basingstoke, England, where Harry was head of the May Brewing Company. It would be twenty years before Harriot would return to live in the United States again.

While Harriot loved England, she never felt entirely at home there. "Deep in my heart I remained an American," she later recalled in *Challenging Years*, especially when she discovered that marrying an Englishman meant that she was forced to give up her American citizenship, a sacrifice only required of women. Her brother had married a Frenchwoman but had retained his American citizenship. Such inequities rankled, and she compensated by never entirely declaring herself a subject of the queen.

Despite these concerns, the family was happy and flourished. Their first daughter, Nora, was born September 30, 1882. A second daughter, Helen, was born in June 1891. Like most American suffragists, Harriot did not approve of the militant tactics of the British suffragettes,[31] but she did find the political atmosphere of England intriguing. British suffragettes were more politically informed than their American counterparts and paid close attention to parliamentary procedures and legislative developments. They were beginning to achieve some success with election to local school boards and were assuming a greater voice in the local educational systems.

Harriot became close friends with militant activist Emmeline Pankhurst, who was feeling like Harriot at the time, "burdened with young children and domestic cares," as she recalled in *Challenging Years.* The two were the disciples of Ursala Bright, pioneer of the English suffrage movement and wife of Jacob Bright, advisor to Queen Victoria. Mrs. Bright and Mrs. Pankhurst founded the Women's Franchise League, which achieved some success organizing among the millworkers and factory hands. It was there that Harriot first realized that the success of the suffrage movement, both in England and the United States, would depend on the involvement of all classes—factory hands, professional women and the wealthy. She came to see that none of these factions could win without the support of the others, a position that she would later find was sometimes in opposition to her mother's.

Indeed, when Harriot came home for a visit in 1894, she was dismayed to find that her mother's suffrage movement was almost entirely dominated by the wealthy, elite women who felt that suffrage would help them to maintain the political influence and status of their class. Worse yet, her mother seemed to agree with them, even going so far as to suggest that a literary restriction should be placed on the ballot. But workingwomen needed the ballot even more than the wealthy, Harriot argued, because the ballot would make such a greater improvement in their lives. This difference of opinion would mark the first time Harriot openly disagreed with her famous mother, and it illustrated how far she had come in the development of her own ideas. Later, Elizabeth would come to agree with her and would also come to the wise realization that when the battle for the vote was won, it would be won by Harriot and her younger colleagues.

In 1896, Harriot's daughter Helen died of whopping cough, and in 1902, the family moved permanently to the United States, purchasing a summer home at Shoreham on the north shore of Long Island. But the America Harriot had left twenty years before was very different from the one she found when she returned. Women's lives were changing; more were

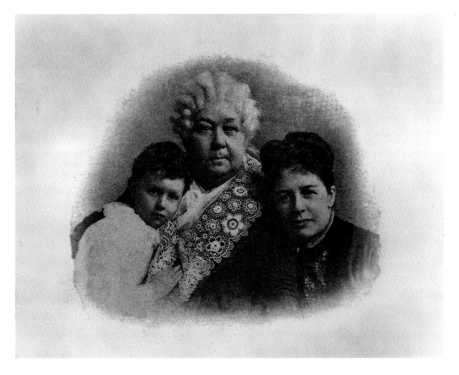

Harriot Stanton Blatch (right), her mother, Elizabeth Cady Stanton, and her daughter (left), Nora, circa 1886. *Courtesy of Bryn Mawr College Special Collections.*

attending college and entering professions and the workforce. A progressive young president, Theodore Roosevelt, encouraged social reform, and many wealthy women found themselves busy establishing settlement houses, working to help the poor and the thousands of new immigrants learn English and assimilate into American society. Developments in science and technology were revolutionizing the labor class. And the American woman suffrage movement was in total disarray.

When her mother died later that year, Harriot unofficially assumed Elizabeth's mantle of leadership. In her autobiography, she wrote, "I was eager to help win the vote for women, eager to finish the work my mother had begun. But the movement was completely in a rut. It bored its adherents and repelled its opponents."[32] Harriot was convinced that a complete change of direction was the only answer. Drawing on her experience in England involving working-class women, she founded the Equality League of Self-Supporting Women. Its first meeting was held January 1907 in a dingy little room in New York City. The membership

fee was twenty-five cents, but there would be no yearly dues, the better to encourage workingwomen to join.[33]

The young workingwomen from factories and sweatshops throughout New York City hoped that the organization would give them a chance to establish some control and influence over their own lives. At the same time, Harriot saw the wisdom in courting the elite class of wealthy women that was also entering the suffrage fray, since such women had the finances and the political connections that the movement so badly needed. But there was tension between these two groups. The wealthy women were afraid of ceding control to the working girls, while the working girls were suspicious of the motives of the elite women they sometimes referred to as "the mink brigade." Since Harriot was equally comfortable in the workplace and the drawing room, she seemed the ideal candidate to serve as a reconciling bridge between the two factions.

In 1908, while keeping control of the Equality League of Self-Supporting Women, she helped her friend Katherine Duer Mackay of Roslyn establish the Equal Franchise Society (EFS), which provided a comfortable organization for many of the wealthy, such as Alva Vanderbilt Belmont and Louisine Havemeyer. But while Harriot sympathized with both classes' desires to establish their own sovereignty within the movement, she always hoped that their differences could be bridged and there would eventually be created a unity of cause among them all, a goal that was never totally achieved.

Even more important than placating warring factions, Harriot recognized the crucial need for suffragists to learn to use the political process to win the vote. No longer could they depend simply on writing articles and letters or collecting names on petitions—voicing politely phrased, timid requests for what should rightly be theirs. They must pay close attention to the political process itself, travel up to Albany and down to Washington, D.C., to meet with congressmen and senators and lobby aggressively for their own interests. Women would have to learn to overcome their distaste for what they might consider unwomanly political practices that involved conflict, opposition, contest and debate.

In 1910, in recognition of the importance of this policy, the name of the Equality League of Self-Supporting Women was officially changed to the Women's Political Union (WPU).[34] The WPU opened an office in Albany and hired a professional woman lobbyist. They kept careful records of elected officials' likes, dislikes, family information and voting records. They worked hard at defeating candidates who did not support suffrage by systematically

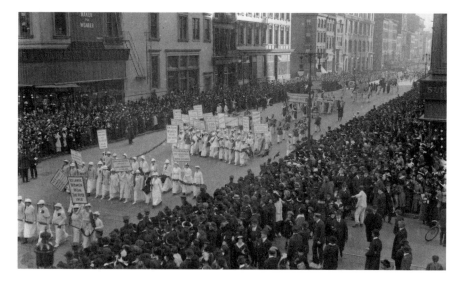

The New York City Suffrage Parade, October 1915, staged during the emotional campaign to convince the New York State legislature to enfranchise New York women. An estimated twenty-five thousand to thirty thousand women marched down Fifth Avenue to show their support. *Courtesy of the Library of Congress.*

canvassing their neighborhoods and distributing literature against them, all traditional political techniques that men had used for years. The WPU also began using the tool of open demonstrations, taking the suffrage movement literally out of the drawing room and into the streets, a marked difference from the more conservative techniques followed by earlier suffrage leaders. In May 1910, more than four hundred women participated in the first large suffrage parade held in New York City. Parades were staged yearly for the next several years both in New York and in Washington, D.C.

When she went home to Shoreham, Long Island, Harriot took the suffrage cause with her, enlisting her friends and neighbors in the campaign. Open-air meetings throughout the island helped to educate the uninitiated. In May 1913, she spoke to a packed Athena Hall in Port Jefferson. According to the *Port Jefferson Echo*, she reminded her listeners that "since women are obliged to obey the laws they should have some say in their making" and that "women need the ballot to solve their own problems." A contingent of Long Island suffragists was invited to march with her on May 3, 1913, in New York City, carrying the banner of the First Senatorial District. In July 1913, she led a weeklong campaign throughout the east end of Long Island, working with other suffragists such as Mrs. Thomas L. Manson of East Hampton and Mrs. Myra Platt of Port Jefferson. She and Harry also used her Shoreham home to relax, finding there

a warm and welcoming place to escape from her demanding schedule. Harry spent much of his time there when Harriot was away.

In 1915, just as the New York State legislature was preparing to vote for the first time on granting New York women the vote, Harriot's husband suddenly died, electrocuted by a live wire hanging over a neighbor's property at their Shoreham home.[35] Harriot returned to England to settle Harry's affairs, and when she returned, she found that rival Carrie Chapman Catt had taken over much of her leadership status. When New York denied women suffrage in November of that year, Harriot decided that a complete change of tactics was in order once again.

For years, suffrage leaders had disagreed on the benefits of pursuing the vote on a state-by-state basis versus a campaign for an amendment to the U.S. Constitution enfranchising all American women at one time. Until 1915, Harriot had supported the state-by-state campaign, believing that the states where women had the vote would help the others. New York was the key. She was convinced that if New York granted women suffrage in 1915, the other states would "come tumbling down." But when the New York campaign failed, a disappointed Harriot decided that she would not wait for it to come back on the ballot again. She would cast her lot with the more militant Congressional Union (CU) of Alice Paul and Lucy Burns in Washington, D.C. Harriot began to see the wisdom of following Alice Paul's tenet of holding the party in power responsible for passing suffrage and for insisting on the passage of a federal amendment.

In 1916, the WPU officially joined with the CU,[36] and Harriot embarked on a national tour to enlist the aid of women in the western states. Western women were far ahead of their eastern sisters. Wyoming had given women the vote as far back as 1869; by 1915, eleven states had the vote, mostly throughout the West.[37] Harriot was intrigued by the concept of asking women who already could vote to help their "eastern sisters" by voting for representatives in Congress who

New York suffrage leaders tried to convince the legislature to grant New York women suffrage again in 1917 and were finally successful. The vote was held on November 6. *Courtesy of the Suffrage First Media Project, author's collection.*

would, in turn, vote for suffrage. The western trip was long and arduous but personally rewarding. Having reclaimed her U.S. citizenship after Harry's death, Harriot formally declared Kansas as her residence and registered to vote there for the first time. Fifty years before, her mother and Susan B. Anthony had held the first state referendum on suffrage in Kansas; her ability to vote there for the first time brought the struggle full circle.

In January 1917, when all attempts to persuade President Wilson to back a suffrage amendment had failed, the NWP began picketing the White House.[38] Day after day, through rain and snow, the pickets stood, holding their banners aloft. Harriot approved of the picketing, and although she herself did not take part, her pleas to potential pickets were moving and inspiring:

> *Women, it rests with us…We have got to bring to the President, individually, day by day, week in and week out, the idea that great numbers of women want to be free, will be free, and want to know what he is going to do about it. Won't you come and join us?…will you not be a silent sentinel of liberty and self-government?*[39]

With the advent of World War I, Harriot began to change the focus of her life yet again. New York granted women suffrage in 1917, and she left the vigorous battle for the amendment in the hands of the younger suffragists, convinced that it would only be a matter of time before victory would be achieved. Instead, she put her prodigious energies into the war effort, heading the Food Administration's Speakers' Bureau and the Woman's Land Army. Her book *Mobilizing Woman Power*, written in 1918, emphasized the contributions European women were making to the war effort, as well as the need for their American counterparts to do the same. After woman suffrage was finally won in 1920, Harriot continued to work with the NWP for passage of the Equal Rights Amendment and for rights of women throughout the world, especially workingwomen. She died in 1940 and is buried at Woodlawn Cemetery in the Bronx.

Harriot Stanton Blatch's legacy as a great leader of the woman suffrage movement does not rest simply on her position as the daughter of its founder. Rather, it rests on what she did with that inheritance, how she shaped it and refocused it to fit the challenges of the life she faced. She skillfully drew on the lessons of the past to plan for the needs of the future, pioneering alliances that were crucial to the movement's success. She may have begun with a desire to vindicate her mother's life's work, but in the end, her efforts created a lasting legacy that was entirely her own.

Chapter 3

LUCY BURNS

1879–1966

She was always…about a thousand times more valiant than I. She was always quite ready for a fight.

—*Alice Paul on Lucy Burns*

The London police station was in an uproar that spring day in 1909. The suffrage meeting at Caxton Hall had just dispersed, emptying one hundred boisterous women, bustling with suffrage fervor, onto the street, marching to Parliament in yet another attempt to demand from the prime minister their right to the vote. As they had suspected, before they could reach Parliament, they were arrested with their leader, Emmeline Pankhurst. They were carted off to the Cannon Row Police Station, all charged with "disturbing the peace." There they were contained in the policemen's billiard room, the only room large enough to hold them all.

One of the demonstrators was Alice Paul, a slender young Quaker woman from New Jersey. Alice had come to England to study economics and was recruited by a school friend to work for the British suffrage movement in her spare time, selling copies of the newspaper *Votes for Women* in the streets and making impromptu speeches to crowds on street corners. It had been a bit of a lark, a new experience, but one she enjoyed. That day at Caxton Hall, they had listened to the inspiring speech of England's foremost champion of woman suffrage, Emmeline Pankhurst. It may have been Alice's first arrest in the cause of suffrage, but it would certainly not be her last, and with crowds of women and constables

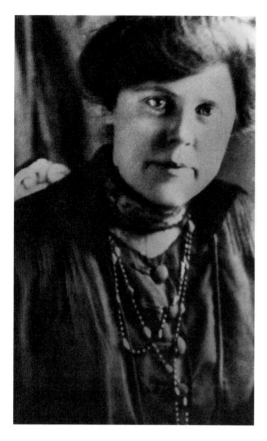

Lucy Burns. *Courtesy of the Brooklyn Historical Society.*

milling about waiting for arrests to be processed, she suddenly had nothing to do.

A tall redheaded young woman perched on a nearby billiard table caught her eye; she spoke with an American accent and had a small American flag pinned to the lapel of her jacket. Alice wandered over to introduce herself to Lucy Burns from Brooklyn, New York. Lucy was studying in Germany and had drifted over to England to study for the summer at Oxford. Both young women were impressed with the vitality of the British suffrage movement in contrast to the American movement, which seemed stagnated and dull. As the only Americans there, the two young women felt an instant kinship, and in that small moment of time, in that shabby, noisy London police station billiard hall, an alliance was forged that would change the course of women's history forever.[40]

Undoubtedly, neither of them could realize at that moment the promise of that inauspicious meeting. They were just two young American students studying abroad, dabbling in the woman suffrage movement, still not infused with the passion that would follow. When Emmeline Pankhurst later invited them to go to Scotland to help her organize the movement there, they were thrilled and not the least impressed by the fact that Mrs. Pankhurst employed a female chauffeur. "Nobody had ever seen a woman chauffeur," Alice Paul later remembered. "It was unusual for a woman to drive a car but to have a woman chauffeur!"[41]

Emmeline Pankhurst and her daughters—Christabel, Adela and Sylvia—were the leaders of the Woman's Social and Political Union (WSPU) in

England, whose motto was "Deeds, not words." Frustrated with their lack of success in convincing the public of the righteousness of their cause, they embarked on a massive publicity campaign, one that began quite harmlessly—with speeches, pageants and leaflet scattering—and eventually turned to more dangerous civil disobedience and violence. They smashed windows, set fires and heckled cabinet ministers. British suffragettes felt that they had tried to succeed along conventional lines but had failed. It was now time to forcibly act. "The women are not impatient," Lucy later told the *Brooklyn Daily Eagle*. "They are simply convinced they can progress no further by a medium of educational propaganda."

Both Lucy Burns and Alice Paul became fully immersed in the British movement, caught up in its electric fervor and impressed with the suffragettes' "moral ardor, optimism, and buoyance of spirit." They joined demonstrations outside cabinet meetings and heckled dignitaries Lord Crewe and Winston Churchill. Demonstrations both in Scotland and London resulted in arrests and imprisonment. In London in 1909, they were arrested together for staging a protest at the Lord Mayor's Banquet in the Guildhall. This time, they were sentenced to thirty days in the dreaded Holloway Jail, where they went on their first hunger strike together in prison and, also for the first time, were forcibly fed.[42]

Alice had been physically weakened by her prison experiences, and she returned home to America in 1910. Lucy stayed behind and accepted a position as a paid organizer based in Edinburgh, Scotland. For two years, she crisscrossed the country, protesting, marching, demonstrating and honing administrative skills that she would later find useful when she returned home. So strong was her bravery in the face of persecution and devotion to the cause that the WSPU awarded her a medal for valor for the "extremity of hunger and hardship" suffered during the hunger strike of 1909. When she finally returned to the United States in 1912, votes for women had become for her "the one subject in the world."[43]

Certainly Lucy's early life in Brooklyn betrayed no hint of the militant activist she would ultimately become. Born on July 28, 1879, she was the fourth of five daughters in a family of eight children. Her parents, Edward Burns and Anna Early Burns, were devout Irish Catholics. The family lived in the prosperous, pleasant neighborhood of Brooklyn Heights. Her father would later become a bank president and held the then unorthodox belief in the value of educating both sons and daughters.[44] Lucy was devoted to her family and was doubtless grateful for her father's support. She and her sisters were educated at Packer Collegiate Institute in Brooklyn, a private school

for girls that stressed the study of the classics, literature and history. Packer students were also encouraged to develop the body as well as the mind through calisthenics, a somewhat revolutionary idea for women of the time.

Lucy graduated from Packer in 1899 and went on to Vassar, where she was said to be an "outstanding scholar." She graduated in 1902 and went on to study etymology at Yale University Graduate School. After a brief, frustrating stint teaching English at Erasmus Hall High School in Brooklyn, she began her study of languages at the Universities of Berlin and Bonn. But she later confessed to being a bit bored with it all and so chanced to cross over to England, where she met Alice Paul.

When Lucy returned to the United States in 1912, Alice Paul visited her at her home in Brooklyn to renew their friendship and to discuss the dismal state of the woman suffrage movement at home compared to the passion of the English movement. Instead of the plodding state-by-state method that many of the American suffragists were pursuing, trying to get each individual state to pass an amendment to their state's constitution granting women the vote, they believed that the only route to success was the passage of a federal amendment granting suffrage at one time to all women throughout the nation. They also embraced the English practice of holding the political party in power responsible for failure to pass the amendment.

But the two passionate young crusaders who had survived prison and force-feeding in England suddenly came up against two formidable foes: Anna Howard Shaw, president of the National American Woman Suffrage Association (NAWSA), and past president Carrie Chapman Catt. The older women were not terribly impressed with the younger women's experiences and believed such violent tactics as they had engaged in while in England were definitely the wrong way to proceed. While they appreciated the young women's passion for the cause, they were not about to give them free rein to "destroy the respectability" of the American movement. And they certainly did not approve of Alice and Lucy's idea of holding the political party in power responsible. NAWSA had never endorsed nor criticized any of the political parties.

But the older women were also aware of a growing impatience among younger women, many of whom had graduated from universities, joined professions and were now clamoring for equal rights—especially the right to vote. Perhaps these two passionate young women could appeal to others while staying within the strict confines NAWSA set for them. So, when Lucy and Alice proposed creating a permanent congressional committee in Washington, D.C., with the distinct goal of lobbying for the passage of

a constitutional amendment, they agreed, with the stipulation that while under the jurisdiction of NAWSA, their committee would be responsible for its own funding.[45]

Alice and Lucy arrived in Washington, D.C., with high hopes but almost no money and no place to begin their work. But they did have a plan, one they believed would garner needed attention both from the press and the government. They would stage a parade on March 3, 1913, the eve of the newly elected President Wilson's inauguration day. (Presidential inaugurations then took place in March.) With the tentative blessing of NAWSA, they plunged headlong into the project. From the beginning, Alice was the strategist who planned the details and assigned the work. Lucy, the tactful, placating voice, drew in friends and supporters. Alice was single-minded, brusque and at times rude. Lucy was cheerful, witty and poised. It was she who had more experience with organizing parades and rallies than anyone else and she who appealed to her Vassar friends for help, including Crystal Eastman and Inez Milholland Boissevain, a beautiful young attorney who would lead the parade on a white horse, holding aloft a suffrage banner and representing the "free woman of the future."

"General" Rosalie Gardiner Jones from Long Island led the New York contingent, along with Elisabeth Freeman dressed as a gypsy and driving a yellow horse-drawn wagon decorated with "Votes for Women" symbols and filled with suffrage literature. The *New York Times* reported that more than 500,000 spectators watched the women march for their cause. At first, the parade seemed to be a huge success. As reported in the *New York Evening Journal*:

> *Lawyer Inez Milholland Boissevain, clad in a white cape and riding a white horse, led the great women's suffrage parade down Pennsylvania Avenue in the nation's capital. Behind her stretched a long procession, including nine bands, four mounted brigades, three heralds, more than 20 floats and more than 5,000 marchers. Women from countries that had enfranchised women held the place of honor in the first section of the procession. Then came the "pioneers" who had struggled for so many decades to secure women's right to vote. The next sections celebrated working women...and college women in academic gowns. Next came the state delegations and, finally...male supporters of woman suffrage...All had come from around the country to march in a spirit of protest against the present political organization of society, from which women are excluded.*[46]

Suddenly, the jolly mood of the crowd began to change. Spectators on both sides of the avenue began pushing into the marchers, grabbing their banners and shouting insults. Masses of unruly crowds blocked the streets. Instead of coming to the aid of the marchers, many of the police aided the attackers, laughing at the pleas of the women for protection. "Some marchers were struck in the face by onlookers, spat upon, and overwhelmed with ribald remarks," recalled suffrage leader Harriot Stanton Blatch, "and the police officers as a whole did nothing." Only under the protection of cavalry troops from Fort Meyer were the women able to complete the march.[47]

Incensed by the callousness of the police, the suffragists were nonetheless delighted to find that by the next day they were hailed as brave heroines, with the press reporting that they had "trudged stoutly along under great difficulties." Even better, they had succeeded in drawing attention away from President Wilson's inauguration. When he arrived in Washington, Wilson is reported to have asked where all the people had gone, as the streets were empty. "They're all watching the suffrage parade," he was told.[48]

Both Lucy and Alice finally won some praise from Anna Howard Shaw and Carrie Chapman Catt for the ultimate success of the parade, despite its problems. "No one ever has done the work which you have done last year, and I know of no one in the world who ever took the risks and went ahead as you…have," Shaw wrote to the two young women. In September 1913, NAWSA allowed the group to officially become the Congressional Union (CU) for Woman Suffrage; its adopted colors were white, purple and gold.

Buoyed by their success, Lucy and Alice asked for and were granted a meeting with President Wilson to submit their demands for a suffrage amendment, the first deputation of women to ever have done so. Wilson was polite but noncommittal. Suffrage leaders always maintained that the movement was not for or against any political party. The CU continued to pressure Congress and, in a flagrant disregard for the wishes of NAWSA, continued to hold the political party in power—the Democratic party and President Wilson himself—responsible for stifling passage of the amendment.

Using skills she had honed in Scotland, Lucy conducted a "school for suffrage," educating young workers in the tactics of the CU. Information was gathered about every member of Congress and listed on index cards: details of how they had voted on suffrage issues in the past, how many children they had, their background, hobbies and issues of interest. Using the information they gathered on those index cards, CU members continued to lobby congressmen, knocking on their doors and demanding to know what they were doing for suffrage.[49] Lucy took over as editor of the Congressional

In one of her well-known publicity stunts, Lucy Burns flies high above Seattle, Washington, dropping suffrage leaflets from the air. *Courtesy of the Library of Congress.*

Union's newspaper, the *Suffragist*, writing stinging editorials designed to keep suffrage in the national spotlight.

National organizers were sent out on the "Suffrage Special" train to the ten western states where women were already enfranchised to urge those women voters to pressure their congressmen to introduce the suffrage amendment in Congress. Lucy herself journeyed out to California to set up a CU center in San Francisco. She traveled throughout the state, making speeches, distributing flyers and enlisting the local women in the cause. She even convinced a pilot from the Washington Naval Militia to fly her over Seattle, dropping leaflets over the suburbs. She was untiring and resolute.

Not surprisingly, the relationship between the CU and NAWSA began to fray. In 1915, Carrie Chapman Catt, recently reelected as president of NAWSA, worried that the aggressive tactics of the CU would detract from the steady, plodding efforts of NAWSA and began to view the CU as a rival. The two groups separated, and in June 1916, the CU officially became the

National Woman's Party (NWP).[50] By 1917, still frustrated with the inaction of Congress and the president, the NWP began its final, defining phase.

January 10, 1917, dawned cold and overcast in Washington, D.C.; snow was predicted. Bearing banners aloft, a line of twelve women left the headquarters of the NWP at Lafayette Street and silently lined up in front of the gates of the White House. Eight carried banners of purple, white and gold. Four carried banners bearing unsettling questions:

MR. PRESIDENT WHAT WILL YOU DO FOR WOMAN SUFFRAGE?

HOW LONG MUST WOMEN WAIT FOR LIBERTY?

No one had ever seen such a spectacle before—the spectacle of women fighting for liberty with weapons no more powerful than words written on flimsy silk banners. At first, the press and government paid little attention. Seemingly amused, President Wilson waved gaily and raised his hat to the pickets as he passed through the White House gates. Everyone believed that the women would soon tire of the demonstration and go home to their families. Bystanders seemed tolerantly amused as well. Many called out to them to "Keep it up. You're on the right track." But as the weeks and months went on, such amused tolerance began to change to anger and violence. The women were vilified and attacked, called "shameless," "sexless" and "crazy." Their banners were ripped from their hands and destroyed. When the United States entered World War I in April and the women continued their vigil, the accusation of "unpatriotic" was added to the list. Lucy was the prime organizer of the picketing campaign, creating the wording on the banners, often using the president's own words to draw attention to his hypocrisy:

WE SHALL FIGHT FOR THE THINGS WE HAVE ALWAYS HELD NEAREST OUR HEARTS, FOR DEMOCRACY, FOR THE RIGHT OF THOSE WHO SUBMIT TO AUTHORITY TO HAVE A VOICE IN THEIR OWN GOVERNMENT.

KAISER WILSON, HAVE YOU FORGOTTEN HOW YOU SYMPATHIZED WITH THE POOR GERMANS BECAUSE THEY WERE NOT SELF-GOVERNED? 20,000,000 AMERICAN WOMEN ARE NOT SELF-GOVERNED. TAKE THE BEAM OUT OF YOUR OWN EYE.

In the year and a half of picketing the White House, more than one thousand women took their place on the line, standing tall and dignified in

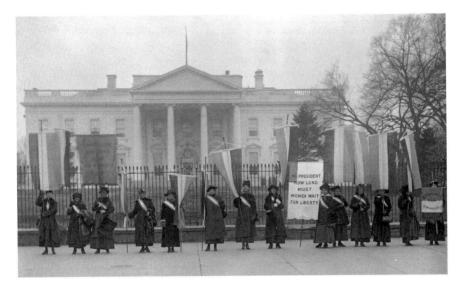

Woman suffrage pickets outside the gates of the White House, 1917. The picketing campaign began on January 10, 1917, and continued on and off for more than a year. *Courtesy of the Library of Congress.*

the snow and rain and later in the heat of summer, holding their banners aloft. Lucy was the first to be arrested and jailed for "obstructing traffic," among other charges, all of which were later dismissed.

She spent more time imprisoned than any other suffragist and, in prison, was the leader the others turned to for comfort and encouragement. With her flaming red hair and her strong, youthful body, she bravely railed against the appalling conditions they were forced to endure—rotten, maggot-infested food and no clean water, toilet or medical facilities. Lucy demanded that they be treated as political prisoners and insisted on their right to habeas corpus. She endured the dreaded Occoquan workhouse in Virginia, where, in order to blunt her influence with the other prisoners, she was sometimes kept in solitary confinement, fed only bread and water and was once chained with her arms above her head to the cell door. To others, she seemed fearless, but in private, she harbored a persistent fear of the rats that scurried around the floors of the cells. "I am so nervous I cannot eat or sleep. I am such a coward I ought to be a village seamstress, instead of a Woman's Party organizer," she once confessed to Alice Paul.[51]

She organized more hunger strikes in prison and fought so valiantly against force-feeding that at one point it took four men to hold her down. Finally, after months of imprisonment and abuse, the suffragists were

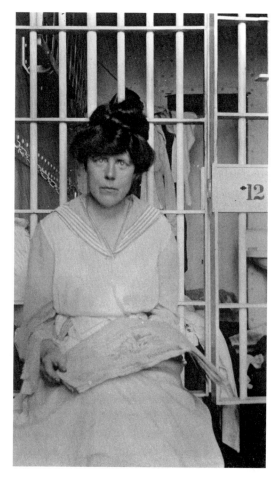

Lucy Burns in jail cell no. 12. Lucy was imprisoned the longest of any of the suffragists. *Courtesy of the Library of Congress.*

released. President Wilson backed down and supported an amendment granting women the right to vote. On January 10, 1918, exactly one year to the day that the picketing had begun, the amendment passed the House of Representatives, 274 to 136 votes, by a margin of 1 vote.[52] It took another year of protest, picketing and campaigning for the Senate to finally pass the amendment on June 4, 1919, 56 to 25 votes. It then began its journey for ratification throughout the states and was finally passed on August 26, 1920. The long journey was over.[53]

But in 1919, Lucy's work was not yet done. She organized another train trip, this one called the "Prison Special," a train car of women who had gone to prison fighting for suffrage. They wore duplicates of their prison garb and traveled throughout the country, in city after city telling their appalling story of being "jailed for freedom."

But Lucy was beginning to tire. As early as 1917, she had expressed to Alice Paul her desire to retire to her Brooklyn home, and only Alice's impassioned pleas to stay the course with her to the end convinced her to continue the fight. In 1919, with the amendment's passage assured, Lucy retired from public life to her family in Brooklyn, where she resumed her active life in the Catholic Church and helped raise an orphaned niece. She died in 1966.

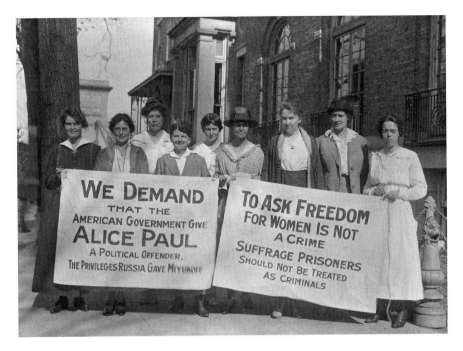

National Woman Party members demanding political prisoner status, which would change the conditions of their confinement. Lucy Burns is third from left. *Courtesy of the Library of Congress.*

When the final account of the last tumultuous days of the battle for woman suffrage was written, it was Carrie Chapman Catt, Anna Howard Shaw and Alice Paul who received the lion's share of the credit. But it was Lucy Burns who convinced others to sign on for battle, and it was her cheerful spirit and her willingness to take the brunt of the abuse that kept so many devoted to the cause. Alice Paul cajoled and even bullied others to help. Lucy won their hearts. And an alliance of two young women forged in a shabby English police billiard hall empowered millions of American women for many years to come.

Brooklyn's Lucy Burns Activist Award is given annually in her honor to those whose work makes a difference in the world of women's rights.[54]

Chapter 4

ELISABETH FREEMAN

1876–1942

I felt that I was watching the advance of a mighty Christian army.
—*Elisabeth Freeman*

The woman clung to the railing for dear life, her gray hair giving witness to her age but certainly not the limits of her stamina. While a burly young policeman beat her, a second fastened his fingers menacingly around another woman's neck, her life literally in his hands. The young suffragette who had come to the rally was shocked at the brutality visited on women who were simply demonstrating for equal rights. When she grabbed the second policeman's armband, he turned on her, twisting her arm, kicking her and crushing her fingers. Suddenly, the fight left him, and he pushed her to the corner and told her to go home. "I came off with two dislocated toes," Elisabeth Freeman later reported, "a badly sprained wrist, three sprained fingers, but not a sprained conscience."[55]

This was not the first time that Elisabeth faced the ire of the authorities for her outspoken support of equal rights for women, and it would certainly not be the last. Her first encounter had been in support of a young woman also being abused by a policeman. That time, she had jumped off a bus to help without even knowing the reason for the fracas. With both of them carted off to jail, she finally was introduced to the fight of women in Britain for equal suffrage and became, as she later noted, "tremendously interested in it."

Elisabeth Freeman had been born in England and raised in the United States. She was returning to England for a visit when she became involved

in the British woman suffrage movement. While proponents in the United States were still demonstrating peacefully, the British women had moved on to a more militant stage. For more than forty years, they had tried every legitimate method to secure the right to vote, to no avail. They felt that their only recourse was to act more militantly.

The leader of the British suffragettes was Emmeline Pankhurst, who for many years had seen the problems of the poor in society firsthand as registrar of births and deaths in her community and, later, as a member of her local school board. She was convinced that unless women had a practical way to influence society through the vote, the appalling conditions facing the poor would never change. The time for "intellectual persuasion" was over. In 1905, she and her daughters—Christabel, Adela and Sylvia—formed the Women's Social and Political Union (WSPU). As we saw in the third chapter, British suffragettes broke windows, disrupted political meetings and demonstrated in front of ministers' houses. They were arrested and imprisoned. Hunger strikes, beatings and forced feedings were common, with subsequent public outcries both in favor and against such tactics. Despite criticism of the violence, Emmeline Pankhurst was dogged in her conviction that "there was never anything worthwhile obtained without fighting for it."[56] Into this highly charged atmosphere came Elisabeth Freeman.

Elisabeth Freeman was born in England on September 12, 1876, the youngest of three children. Her mother, Mary Hall Freeman, left her husband and immigrated to the United States when Elisabeth was a young child, bringing Elisabeth and her two siblings to live at St. Johnland, an orphanage on the rolling hills of the north shore of Long Island.[57] St. Johnland had been founded in 1866 by minister William Muhlengerg as a rural haven for the destitute and needy, both adults and children.[58] Mary found work at the orphanage, and the children probably attended school there. Life could not have been easy for the small family, living in such rural, modest circumstances. St. Johnland was set on five hundred acres of woodlands and fields, in an area of Long Island that was isolated from other communities. Mary eventually moved with the children to other neighborhoods around the New York area, but the family was not wealthy, and they struggled to survive.

With such reduced circumstances, college was not an option for young Elisabeth, so she sought relief from her restlessness and boredom by attending the local Salvation Army meetings. The Salvation Army was founded in England in 1865 by William Booth and expanded its mission to the United States. A branch of the Christian faith, the Salvation Army seeks to aid the poor, homeless, ill and underprivileged. In 1908, founder Booth announced, "I insist

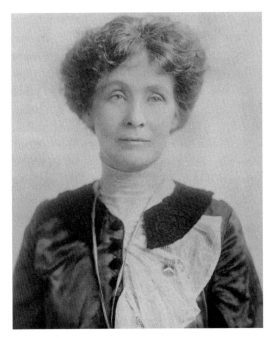

Mrs. Emmeline Pankhurst, leader of the British suffrage movement. British women preferred the term "suffragette." *Courtesy of the Library of Congress.*

on the equality of women with men. Every officer and soldier should insist upon the truth that woman is as important, as valuable, as capable and as necessary to the progress and happiness of the world as man."[59]

Such an egalitarian view, coupled with a devotion to helping the needy in society, appealed to Elisabeth, and she developed a fierce inspiration to fight the injustices of the world. This inspiration would soon find fertile ground in her quest for equal rights for women and would define her work in the woman suffrage movement. A visit to England with her mother in 1905 and the subsequent encounter with the imprisoned young suffragist were the final sparks that ignited Elisabeth's passion for the suffrage cause. Most would consider sharing a jail cell an experience to be avoided. For Elisabeth, it proved to be the formal beginning of a life devoted to fighting for social justice. After years of feeling rootless and unchallenged, she finally found a focus for her sincere belief that people could change the world for the better through passion and hard work.

In England, Elisabeth was introduced to Emmeline Pankhurst. "When I first took her hand," she later recalled, "I felt I was clasping the palm of a saint."[60] She immersed herself in the activities of the WSPU, joining its demonstrations, distributing literature in Trafalgar Square and making speeches at its rallies. She discovered there a familiar religious zeal, much like that exhibited at meetings of the Salvation Army. Watching a parade of suffragettes on Downing Street, she commented, "As I looked down the line of marching women I saw that their faces were turned to heaven and there was that expression which awed and uplifted me. It was as though the early Crusaders had been reincarnated in them. I felt that I was watching the advance of a mighty Christian army."[61]

She also soon learned that the police in England could be fierce opponents who seemed to delight in rounding up and jailing as many suffragettes as they could. As had other American girls such as Lucy Burns, Elisabeth was sent to the dreaded Holloway prison twice. Nicknamed "Lady Betty," she defended the group's violence, steadfastly maintaining that the suffragettes were careful in their destructive ways. "A brave suffragette," she insisted, "never did anything that was a menace to any life but her own." Stone throwers only targeted empty carriages, she insisted. Houses were searched to make sure they were empty before torches were thrown.[62] Elisabeth was arrested a total of nine times and was awarded the prized "prison pin" by the WSPU for her sufferings, a medal she wore proudly.[63]

In 1911, after six years in England, she returned to the United States a skilled public speaker and a gifted organizer, but she found a very different movement agitating for woman suffrage than when she had left in 1905. The leaders of the movement in the United States had not yet resorted to the picketing and demonstrations of their sister British suffragettes and had thus not yet experienced violent reprisals. But all that was about to change.

The years after the Civil War had seen a period of apathy in the movement and had also been characterized by infighting among the leaders. The National Woman Suffrage Association (NWSA), led by Susan B. Anthony and Elizabeth Cady Stanton, believed in campaigning for a federal amendment; the American Woman Suffrage Association (AWSA), led by Lucy Stone and her husband, Henry Blackwell, believed in working to achieve suffrage on a state-by-state basis. The union of the two organizations in 1890 finally helped to ease the conflict, and the resulting National American Woman Suffrage Association (NAWSA) was dedicated to securing enough state victories so that a federal amendment would be ensured.

But their methods were mostly passive. Meetings were often social gatherings in women's homes with little or no controversial subjects discussed. As we see in other chapters, younger leaders of the movement were becoming discouraged with these timid methods and began advocating for change, and Elisabeth Freeman joined their ranks. But Elisabeth believed that the violent tactics of the British suffragettes would not be successful in America because "in America where men are reasonable and quick-witted, discussion and agitation will succeed."[64] Instead, she set out to further the cause by a steady, deliberate campaign to attract the attention of the media any way she could.

During a street cleaners' strike in New York City, Elisabeth led a delegation of women from the Wage Earners League for Woman Suffrage to see New

York City mayor William Gaynor, offering to clean the streets themselves. (The mayor called her a crank.) She had pictures taken of herself with a bear and was arrested while demonstrating with striking garment workers. She spoke between rounds at prizefights and at county fairs. Elisabeth courted media attention and was often able to charm the press while garnering attention for the cause.

Because of her British experience, she was a popular speaker. Sands Point suffrage leader Harriet Burton Laidlaw praised her as "one of those few who not only inform the intellect but who lift up the heart, and have the capacity to transform belief into action."[65] But unlike her wealthier friends, Elisabeth needed money to support herself and her mother. She worked as a professional speaker for the William Feakins Speakers Bureau in 1911 and later wrote for the suffrage paper the *Woman's Journal* for a salary of $125 per month.[66]

On March 25, 1911, a fire broke out at the Triangle Shirtwaist Factory in New York City's Greenwich Village. The factory employed mostly young women, Jewish and Italian immigrants, some as young as fourteen years of age. The owners had locked most of the doors leading out of the building to discourage theft, and as the young workers rushed to escape, they were trapped by the smoke and flames. The fire claimed 146 young lives, almost all of them young immigrant women. To Elisabeth and other proponents of suffrage, the fire was a perfect example of how the vote could improve people's lives—including young workingwomen, who would thus have some say in the laws under which they lived and worked. When the owners of the shirtwaist factory were acquitted of any wrongdoing, Elisabeth joined with others to speak out at meeting and rallies against such a blatant disregard for human life, thus linking the need for woman suffrage to other progressive issues of the day.

It is unclear where Elisabeth Freeman met Rosalie Gardiner Jones—perhaps at a rally somewhere in the New York area. Certainly, the young women came from distinctly different backgrounds: Rosalie was wealthy, descended from a socially prominent family on Long Island, and Elisabeth's family came from modest means and had to work for a living. But the two were joined by a passionate devotion to the fight for woman suffrage. Rosalie was a natural leader who had the financial means to wage an extensive campaign. Elisabeth had an innate talent for exploiting their activities to garner the most attention from the press. Together, they made a formidable team.

In the summer of 1912, when the Ohio Woman Suffrage Association was campaigning for a state constitutional amendment granting women suffrage, the two friends decided to travel there to offer their aid to fellow suffragists.

Fellow marcher Elisabeth Freeman, with her horse and wagon, on the way to Washington with "General" Jones. *Courtesy of the Library of Congress.*

But they would not travel by conventional means. "We could have driven in an automobile," Jones later recounted, "but then we wouldn't have to stop so often" and thus would have missed chances to talk to farmers, shopkeepers and people in small towns.[67] No, instead they would travel by a little yellow wagon, pulled by a horse affectionately named "Suffragette."

It is not hard to imagine the cheerful, fun-filled spirit of shared energy felt by these two young women engaged in such an unorthodox project. Rosalie had the yellow wagon shipped to Warren, Ohio, where the two retrieved it and traveled through the state, speaking on street corners and at fairs, distributing literature and selling suffrage buttons and cards. "We shall spend no money on ourselves during the trip," Jones told a reporter. "We shall live by our wits, asking farmers to put us up for the night, or at least give us breakfast or supper."[68]

The campaign against suffrage in Ohio was too strong to defeat, and the amendment failed. But the friendship of Rosalie Jones and Elisabeth Freeman was firmly cemented by their time spent together, and they collaborated on many other publicity projects over the next few years. They crisscrossed Long Island, organizing marches in Hempstead, speaking at rallies in Sayville and bringing the little yellow Suffrage Wagon along to raise both spirits and funds. With Rosalie as the organizer

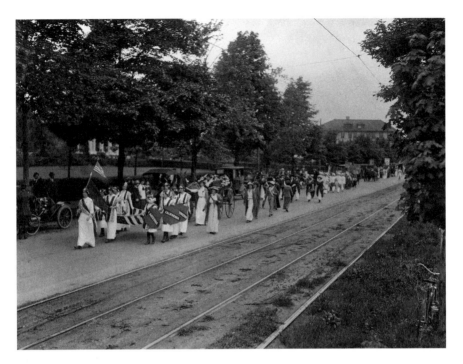

Suffrage pageant, Long Island, May 24, 1913. The *New York Tribune* reported a "Streak of Yellow from Mineola to Hempstead," the color chosen by the marchers for suffrage banners and clothes. *Courtesy of the Library of Congress.*

and Elisabeth as the speaker, they toured the island from Brooklyn to the east end.[69]

Theirs was one of the most powerful and enduring relationships resulting from the shared goals of the woman suffrage movement. But Elisabeth did not have Rosalie's financial independence, so in 1916, she accepted a position from the Texas Woman's Suffrage Association to try to promote the campaign there. The train ride to her new job took her through Atlanta, out through desolate regions of the Midwest, places she had never been before. Along the journey, she noted in a letter to her mother:

> *The journey yesterday was oppressive and only relieved by a nice view of the Blue Ridge Mountains in West Virginia. The hovels & poverty along the way make me sick. The R.R. Stations have signs which reflect discredit upon American Democracy. One side has "Whites" and the other "Blacks" and some places "Colored Persons."*[70]

She had not seen such poverty in New York and was offended by the overt racism she observed throughout the South. Still, she was greeted warmly in San Antonio and plunged right to work. It was while she was working in Texas for suffrage that Elisabeth became immersed in another civil rights issue that would further engage her strong sense of moral justice.

Despite many social, educational and financial gains since the end of the Civil War, African Americans throughout the southern regions of the United States still suffered from racial persecution, including the egregious practice of lynching of unarmed blacks by vigilantes. On her train trip down to Texas, Elisabeth had met the secretary of the National Association for the Advancement of Colored People (NAACP), Roy Nash. In May, he wrote to Elisabeth asking for her help in the investigation of a lynching in Waco, Texas, of a young black boy, Jesse Washington. Nash believed that Elisabeth's travels for her suffrage work would offer her an excellent cover for investigative work concerning the lynching. "Will you not get the facts for us?" he asked. "Your suffrage work probably will give you an excuse for being in Waco…your presence will not be noticed."[71]

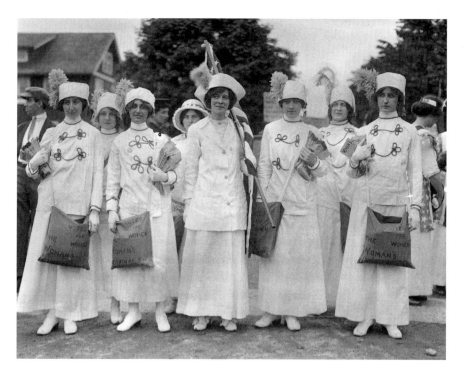

Elisabeth Freeman and the "Suffrage Newsgirls," selling copies of the *Woman's Journal* at the Long Island pageant, circa 1913. *Courtesy of the Library of Congress.*

Elisabeth spent the next two weeks interviewing the judge, the accused's family, taking photos and calling the public's attention to these atrocities. She reported on the young man's brutal murder at the hands of a crowd: "He was dragged to the tree in front of the city hall, and in front of the window of the mayor's office with the mayor looking on and the photographic apparatus also installed in the mayor's office."[72]

Much the same way she had with her devotion to suffrage, she jumped at the chance to work for this new cause. This led to two national speaking tours on behalf of the NAACP, working with such black leaders as Mary Burnett Talbert, using the skills she had honed working for suffrage to encourage black communities to actively join the anti-lynching campaign.

In January 1917, she returned to Washington to join other suffragists picketing the White House and to lobby to prevent our nation's entry in World War I. There her work for suffrage seems to have come to an end. Perhaps she saw the inevitability of the success of the suffrage cause and felt that it was time to turn her considerable energies to other causes. She campaigned for presidential candidate Charles Evans Hughes and traveled in 1919 throughout the country as a paid organizer for the People's Council. Throughout her life, she continued to lobby for peace and worked to better the lives of the blind, needy and disabled. She died in 1942.

From her early days as a militant British suffragette, Elisabeth Freeman fought for social justice and equality. She was a gifted speaker who had a talent for convincing others of the righteousness of her cause; a talented publicist and marketer who found myriad innovative and daring ways of attracting attention; and a passionate crusader for human rights and social justice. Her fiery spirit and formidable energies helped lift the woman suffrage movement out of the doldrums, into the attention of the American public and, ultimately, on to victory.

Chapter 5

LOUISINE HAVEMEYER

1855–1929

*I lifted the torch as high as I could, and for once I did not have to think…
the words came to me as if by inspiration. The torch stood for liberty and
freedom—the freedom we were seeking.*
— *Louisine Havemeyer*

The young woman who rang the doorbell was in a rush, anxious to rid
herself of her unwieldy burden. Her train back to the city was due to
leave in four minutes, and the station was far away. When the door opened,
she wasted no time on pleasantries. "Here, take it," she insisted, "it's the
Suffrage Torch," and into Louisine Havemeyer's outstretched hands she
thrust a large, dark, wooden object, still sticky with wet paint. After a few
mumbled instructions and a few harried reminders, the door slammed, and
to the sound of spinning tires, she was gone.

Louisine Havemeyer was a noted collector of fine art; since girlhood, she
had spent many years and astoundingly large sums of money amassing one
of the most impressive private collections of art treasures in the world. She
knew beauty when she saw it, and the misshapen, sticky item in her hands
certainly came nowhere near traditional beauty. "What has a torch to do with
suffrage, anyway?" asked her startled hostess, who was still dumbfounded by
the little doorway drama she had just witnessed.[73]

But Louisine Havemeyer knew quite well what the torch had to do with
suffrage. The torch she held wasn't beautiful in a conventional sense. But as
the symbol of the movement that she and so many others had worked on

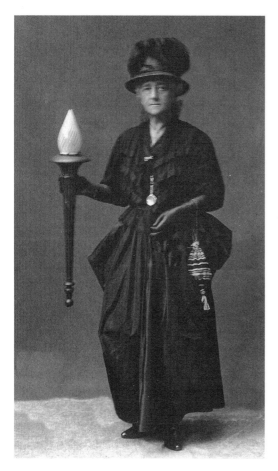

Louisine Havemeyer holds her Suffrage Torch high. She later transferred it to a delegation of suffrage leaders from New Jersey in a colorful ceremony in New York Harbor, in the shadow of the Statue of Liberty. *Courtesy of the National Woman's Party Collection, the Sewall-Belmont House and Museum, Washington, D.C.*

for so long, it bore a rare beauty of its own. The torch was a symbol of the liberty and freedom that would be conferred on women when they finally could vote. The next day, she gathered her things, packed up the ugly Suffrage Torch and carried it on to its date with history.

Louisine Elder Havemeyer was born in New York City in 1855. Her father, George W. Elder, had made his fortune in the sugar industry. Her mother, Mathilda Waldron Elder, was a firm believer in woman suffrage and in her youth had enjoyed friendships with both Susan B. Anthony and Lucy Stone. Louisine was a lively and curious child. Her early education was private, but as a young woman of fifteen, she was sent to Paris to study, where she was introduced to the artist Mary Cassatt, whose influence would inform her education and ultimately her purchases of art for many years to come.[74]

Mary Cassatt was born in 1844 in Pennsylvania to a wealthy and prosperous family. Her father was a traditionalist who did not believe in wasting education on girls, but despite this reluctance, he allowed Mary to attend the Pennsylvania Academy of Fine Arts. In 1866, discouraged by the patronizing attitude of the instructors and her fellow male students, she convinced her father to allow her to study in Paris, where she worked primarily as a portrait painter.[75] Cassatt would go on to become one of the

leading female Impressionists, specializing mainly in charming portraits of women and children.

Mary Cassatt introduced the sensitive sixteen-year-old Louisine to the beautiful works of Impressionists such as Degas, Manet and Pissaro. Louisine fell in love with Impressionism and was so taken with Degas' talent that she scraped together her "pin money" to purchase one of his works entitled *Répétition de Ballet*, for which she paid F500 (about $100), thus becoming Degas' first American patron.[76] Louisine's friendship with Cassatt lasted throughout her lifetime, and it was by following Cassatt's unerring advice that she and her husband were able to collect works of many different European artists. "I call her the fairy godmother of my collection," Louisine later remarked in her memoir *Sixteen to Sixty*, "for the best things I own have been bought on her judgment and advice."[77] Cassatt, too, was an ardent suffragist. "Work for suffrage," she once advised Louisine, "for it is the women who will decide the question of life or death for a nation."[78]

By the time Louisine married Henry (Harry) Havemeyer in 1883, she was an accomplished art collector. Like Louisine's father, Harry had also made his fortune in the sugar trust, a consolidation of seventeen sugar refining plants in the East and South of the United States. He had been an art collector before their marriage, and Louisine soon convinced him to begin collecting the work of Degas and other Impressionists. He also shared Louisine's passion for suffrage, once remarking to her, "If a woman does not know how to vote she'd better get busy and learn."[79]

Harry established the housing development of Bayberry Point on the Great South Bay in Islip, Long Island, where the young couple was part of the summer colony. In winters, they lived in Manhattan, but they traveled extensively through Europe, building their considerable collection of art. Together, they had three children, shared a long and happily married life and established one of the most impressive private art collections in the world.

When Harry died in 1907, fifty-three-year-old Louisine entered a dark period of her life that even her joy in art and her devotion to her family could not assuage. Her art purchases ceased, and she descended into a deep depression, at one point even contemplating suicide. She began to write her memoirs, and it was through the prism of these happy memories that her joy in life was rekindled. She wrote in *Sixteen to Sixty*, "It was only when the sorrow came and I reeled beneath the blow, and listened in the silent hours of loneliness to the echoes of the past…that my memoirs were begun." Slowly, she returned to an active life in which the battle for woman suffrage began to play a leading role.

By 1910, the woman suffrage movement in the United States was entering a critical phase. As we saw in previous chapters, after years of a determined but somewhat passive crusade, many of the younger suffragists were restive, frustrated by the plodding pace preferred by the older activists such as Carrie Chapman Catt and National American Woman Suffrage Association (NAWSA) president Anna Howard Shaw. The younger women were tired of waiting for Congress to act and were determined to force the older suffrage leaders into a more dynamic and active role.

In 1910, Harriot Stanton Blatch, daughter of Elizabeth Cady Stanton, had formed the Women's Political Union (WPU), aggressively recruiting wealthy women to the cause. Blatch had valid reasons for focusing on wealthier women: they had money to spend, and a viable suffrage movement needed money. They had time on their hands and were related to politically influential men. But to most wealthy women, appearance and social standing were of utmost importance to them and to their families. It could not have been easy for them to leave their comfortable homes to march in the streets or make impromptu speeches on street corners, activities that were often frowned on by friends and families. Louisine Havemeyer's children were horrified by her suffrage work, and Katrina Ely Tiffany, daughter-in-law of Louis Comfort Tiffany, never received her husband Charles's approval for such "radical" activities.

After her period of mourning was over, Louisine began to speak in public about suffrage. She credited Harriot Stanton Blatch with developing this skill, since Blatch was the first to encourage her. "It was Mrs. Blatch who insisted that I could speak; that I must speak, and then saw to it that I did speak. I think I spoke just to please her," she later wrote in an article in *Scribner's* magazine in 1922. "I soon became a seasoned campaigner," evidenced by the invitation she received in 1915 to speak at Seneca Falls at the centennial of Elizabeth Cady Stanton's birth. Louisine was a candid speaker whose down-to-earth enthusiasm endeared her to her listeners.

In 1913, the WPU opened a "Suffrage Shop" in a storefront in New York City. The shop offered a comfortable place where men and women could hear suffrage speeches, purchase all manner of suffrage memorabilia—including pencils, buttons and even suffrage cigarettes—and receive up-to-date information about the progression of the campaign. The shop's activities were presided over by many of the wealthy female suffragists, including Helen Rogers Reid, wife of the publisher of the *New York Herald*, and Louisine often took a turn there as well, bringing her grandchildren to Grandmother's Day, a popular celebration at the shop. "We held some very brilliant meetings at the Shop," she later recalled

"Such were those when we answered the antisuffragists' criticisms, when we had one minute discussions for and against suffrage. On those days the hall was packed to the doors."[80]

Louisine did not just lend her voice and her labor to the suffrage movement—she also lent her considerable art collection. In 1915, she organized an exhibition entitled Masterpieces by Old and Modern Painters to be held at the M. Knoedler Gallery in New York. This was the only time Louisine allowed her pictures to be exhibited collectively; the entrance fee was an astounding five dollars. She herself commissioned the creation of posters advertising the exhibit and used her newly developed speaking skills to inform the attendees about

Anti-suffrage groups tried to paint suffragists in an unflattering light, such as this card that shows a suffragist paying other women to support the cause. *Courtesy of the Suffrage First Media Project, author's collection.*

the art of Degas and the other masters in the show. Since the exhibit was for the benefit of suffrage, it engendered some controversy. The owner of the Knoedler Gallery was threatened by several customers with withdrawal of their patronage, and some of Louisine's friends disapproved as well, but she was determined to see it through. "We needed the money so badly," she later explained, and in the end, some of those reluctant friends eventually found themselves contributing to the suffrage cause.

In 1915, woman suffrage was on the November ballot in New York State for the first time. In order to focus much-needed publicity on the election, Harriot Stanton Blatch came up with the idea of a Suffrage Torch, a symbol of the liberty and freedom the suffragists were seeking, much like the torch

held high by the Statue of Liberty in New York Harbor. The Torch would be carried by Mrs. Thomas L. Manson from the eastern end of Long Island and delivered to Louisine, who would then take it across the farmlands and through the villages of New York, up to the northern limits of Buffalo and back down again. When the Torch returned to Long Island, Harriot Stanton Blatch herself would ceremoniously hand it over to a New Jersey delegation in the middle of the Hudson River, to the popping of flash bulbs and the cheering of supportive crowds.

The Torch was delivered to Louisine at the Long Island home of a friend, and she was instructed to appear at the Brooklyn Academy of Music the next day for the beginning of the journey. "And don't forget," she was reminded, "you are to speak on the Torch." Despite her nervousness, Louisine spoke that day to the largest crowd she had ever faced, bearing the Torch high and reminding all who listened of the noble cause it represented. She then carried it throughout New York State on a ten-day tour, making speeches from the back of her car, appearing at garden parties, visiting the state fair and challenging those who were against suffrage with the passion and sincerity of her beliefs. But just at the time Louisine and the Torch returned to New York City to be handed over to the New Jersey delegation, tragedy struck. Harry Blatch, Harriot's husband of thirty-four years, was accidentally electrocuted and died at their Long Island home. Blatch asked Louisine Havemeyer to take her place at the ceremony.[81]

The day was overcast as crowds gathered on both shores of the Hudson River to watch the two tugboats meet in the middle of New York Harbor under the shadow of Lady Liberty herself. The boats were filled with reporters, photographers and suffragists, and as purple and white flags flew and horns gaily blew, Louisine made a moving speech (despite an attack of seasickness). During her journey with the Torch, she had been struck, she said, by the affect the Torch had on women she met along the way. The women truly felt that the Torch was a symbol of their progress in their fight for justice. She then ceremoniously transferred the Torch into the waiting hands of the New Jersey delegation, and it was sent on its way, carrying its message of freedom through New Jersey and on to the southern states.[82]

The suffrage measure was defeated in New York State that November, but two years later, on November 6, 1917, women in New York State were finally granted the right to vote. The focus then changed to the passage of the federal amendment to the Constitution, and Louisine Havemeyer entered the most dramatic phase of her suffrage career.

In New York Harbor, Louisine Havemeyer (right) passes the symbolic Suffrage Torch to the New Jersey delegation, August 1915. *Courtesy of Bryn Mawr College Special Collections.*

By 1916, with President Wilson still refusing to commit to the national suffrage amendment, the National Woman's Party, headed by Alice Paul and Lucy Burns, decided to take more drastic action. On January 10, 1917, a line of silent protestors, carrying banners with slogans, took their places outside the gates of the White House. For many long months, through the heat and the cold, they kept their picketing vigil. (For more about the White House pickets, see the third chapter.)

Louisine did not take part in the picketing, at least not right away. "No picketing and no prison for me, I had always laughingly said to Miss Paul," she recounted later. "I don't like the thought of either one!"[83] Her fears were well founded, as over the next few months, the picketers were arrested for a series of trumped-up charges—disturbing the peace, marching and meeting without a permit. When they protested against such injustice with hunger strikes, they were force-fed and brutally beaten. In January 1918, after one year of picketing, protests and imprisonment, the House of Representatives finally passed the suffrage amendment with just one vote over the necessary two-thirds majority. But the Senate refused to act, and by August of that year, the White House demonstrations had begun again. Even when President Wilson reversed his stand and weakly supported the suffrage

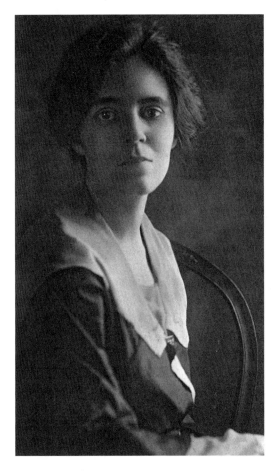

Alice Paul, leader of the National Woman's Party, who convinced Louisine Havemeyer to be imprisoned for the cause. *Courtesy of the Library of Congress.*

amendment on October 1, 1918, the Senate again failed to pass the measure by just two votes. The women again demonstrated and again were arrested and jailed in a vicious cycle of unwarranted violence and injustice.

Since President Wilson had not been able to command Senate support, a new strategy was adopted: burning the president's words in urns outside the White House gates and ultimately burning the president himself in effigy, a daring and potentially dangerous move. Because Louisine Havemeyer was a well-respected and revered figure in the movement, Alice Paul turned to her for help. Her support at this critical junction might just sway the Senate to action. When the first watch fire was set on January 1, 1919, Alice Paul called Louisine. "Bring a grip," she was told, in case they should have to go to prison. Despite her fears, Louisine did as she was told. "How could I do less with such examples before me?" she later asked.[84]

The group gathered across the street from the White House, and Louisine led the march to the White House gates, holding her flag high. When the time came for her to burn the president in effigy, she followed the instructions of Lucy Burns, lit a match to a small bundle of papers and was immediately arrested. Thirty-eight women were arrested with her and carted off to jail.

Alice Paul's strategy for involving Louisine was not just to have her take part in the effigy-burning demonstration, but also to have her arrested and

imprisoned so that she could then qualify to join the "Prison Special," a motor caravan of ex-prisoners that would tour the country, telling of their experiences and crusading for suffrage. But Paul's plan backfired when the willing Louisine and her fellow activists were incarcerated not in a comfortable city police station but rather in a filthy jail that had been abandoned ten years before because it had been judged unfit for human habitation. Louisine was horrified, not just by the prison conditions, but by the brutality and cruelty they suffered after their arrest. In her later article in *Scribner's*, "The Prison Special," she wrote:

> *Where was my Uncle Sam? Where was the liberty my fathers fought for... the democracy our boys were fighting for?...The women of America were to languish in a dirty, discarded prison because they dared to ask for their democracy while our President was hawking democracy abroad...and would give it to any little nation that would stand still long enough to receive it.*

Louisine only stayed in that damp, cold prison for a few days, but it was enough to galvanize her into action. When the "Prison Special" left the following week, she was one of the first on board. The caravan of cars holding twenty-nine ex-prisoners worked its way through the southern states of South Carolina, Florida and Texas and north through Wisconsin, Illinois and Michigan. The women dressed in replicas of their prison garb, and all along the route, they spoke to whomever would listen, bringing their tales of prison, telling how they had suffered for freedom and speaking to immense audiences in meeting halls and to small groups in local parks. Twenty-nine days later, they returned to New York City, exhausted but proud and confident. They had spoken to more than fifty thousand people in those twenty-nine days.[85]

On August 26, 1920, after seventy-two years of struggle, woman suffrage finally became the law of the land. In 1922, Louisine wrote two articles for *Scribner's* magazine about her suffrage activities, vividly describing the hardships she and other women had suffered during their protests, marches and imprisonment. She continued to collect and lecture on art until her death in 1929.

Louisine Havemeyer was wealthy and privileged and could have lived her life in quiet luxury. She chose instead to put her wealth to work for justice, to chance the ridicule and ostracism of family and friends to champion a cause she believed in, a cause that would ultimately improve the lives of millions of

women. When Louisine died, she left a substantial number of her paintings to the Metropolitan Museum of Art in New York City, a "munificent bequest." But it could be argued that her work for woman suffrage was no less valuable a legacy.

Louisine Havemeyer, like Alva Vanderbilt Belmont, greatly admired Joan of Arc, once commenting that the world was better off because a peasant girl in Domrémy was not afraid of prison. The same could certainly be said of the redoubtable and stalwart Louisine Havemeyer herself.

ROSALIE GARDINER JONES

1883–1978

We must press on.
— *"General" Rosalie Gardiner Jones*

The troops marched across long distances, through cold driving rains, over bridges crusted with ice and along roads slippery with newly fallen snow. They passed through territories both hostile and friendly, on feet so blistered they bled and in clothes soaked through to their bones. As they marched, they carried their banners aloft, distributing leaflets and flyers and spreading their message to all who would listen and even to some who would not. At times, rumbles of dissention in the upper ranks drifted down the line of marchers. Some dropped out, while others took their place. But a great cheer erupted, all adversity forgotten, when the end came into view—the gleaming capital building in Albany, New York. The commanding General Rosalie Gardiner Jones led her troops triumphantly into town to bring their message to Governor William Sulzer of the pressing need for women to be granted the right to vote.[86]

Rosalie Gardiner Jones belonged to no official army—indeed, in 1912, there were no female generals anywhere in any military. But her acceptance of personal responsibility for marshaling her troops and her insistence on military precision for such a daring escapade led her followers to dub her "General," a title she was only too happy to accept.

She was born in 1883, one of six children of a wealthy and prominent Long Island family whose ancestors immigrated before the American

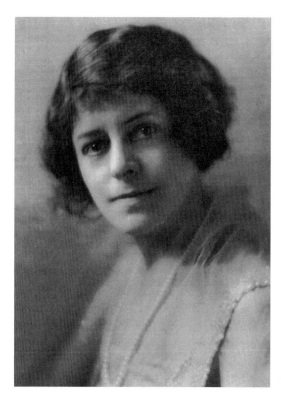

"General" Rosalie Gardiner Jones. *Courtesy of the Suffolk County Historical Society.*

Revolution. Her ancestor, Lion Gardiner, was born in Scotland and was one of the few colonists to be given a land grant by the Crown, a small, star-shaped island just off Montauk Point at the eastern end of Long Island that is still known as Gardiner's Island.[87] Future descendants would include Julia Gardiner, who became the wife of President John Tyler in 1844.

Rosalie's father, Oliver Livingston Jones, was a physician who married his first cousin, Mary E. Jones; the family owned extensive land throughout Oyster Bay, Cold Spring Harbor, out across the north shore of Long Island and in other parts of the country. A study of Rosalie's early life betrays no hint of the rebellious nature that would later assert itself. She lived the usual life of a young woman from a prosperous and socially prominent Long Island family. The society columns of local newspapers report her attending dances and receptions, as well as when she served as maid of honor at her brother's wedding. She was a member of the Junior Guild and was listed as one of the young debutantes seen dancing at Delmonico's supper club in New York City. She attended Adelphi University and graduated from the Washington, D.C., College of Law.[88]

Like others before her, it was while on a trip to England that she first became fully aware of the suffrage movement, as well as the glaring differences between the British movement and the one being waged by suffragists in the United States. Emmeline Pankhurst and her daughters were the leaders of the British Woman's Social and Political Union (WSPU) and were frustrated by the refusal of Parliament to consider granting women suffrage. Their motto of "Deeds, not words" encouraged

window smashing, house burning and relentless picketing of political meetings and parliamentary proceedings.

Rosalie disapproved of the British activists' violence but came home to the United States inspired to breathe some life of her own into the somnolent American suffrage movement. Her first public speech promoting votes for women was in the village of Roslyn at the base of the clock tower, where she fought down nervousness and panic to speak to a crowd of three people and a dog. But by 1911, she had expanded her base, joining forces with suffrage leaders Harriot Stanton Blatch and Alva Belmont, wealthy women whom she had probably met through her family's social ties. The three spoke at the corner of Wall Street and Broadway in New York City to a bit larger crowd than Rosalie's first, and although they were pelted with tomatoes and eggs, their fervor was undiminished.[89]

Rosalie had finally found an issue that ignited a passion she had never felt before. She joined the Nassau County branch of the National American Woman Suffrage Association (NAWSA) and soon was serving as its president. She renewed a friendship with a young woman who had been born in England but raised in the United States, Elisabeth Freeman (see the fourth chapter). Elisabeth did not share Rosalie's wealth or family background—her family was of modest means and worked for a living—but the two young women did share the same fiery passion to fight for suffrage. In May 1912, they clambered into a wagon painted yellow and plastered with suffrage flyers, pulled by a horse aptly named "Suffragette." Together, they traveled throughout Long Island, peddling tea and cake and selling suffrage literature and buttons in an effort to raise funds for the suffrage battle then being waged in Ohio. The *Long Islander*, a local newspaper, reported that they drove across Suffolk County and through Shoreham, Port Jefferson, Smithtown and Northport in their yellow wagon, giving speeches and selling copies of their newspaper, the *Woman Voter Daily*. The caravan then moved through Nassau County, speaking at Freeport and Garden City, finally returning to Rosalie's home in Cold Spring Harbor.

By 1912, the battle for woman suffrage in Ohio had reached a critical point. After years of effort, suffragists had finally convinced legislators to propose an amendment to the state's constitution granting women the right to vote. Certainly, if such a politically vital state as Ohio passed suffrage, the nearby states of New York and New Jersey might see success as well. Suffragists were pouring into Ohio to offer their support to the local groups. NAWSA asked the two young activists if they would try to stir up some fervor for the amendment vote by visiting Ohio in their attention-grabbing yellow horse-drawn wagon.

It was just the type of political activism that appealed to the two young women. Rosalie had the horse and wagon shipped out to Cleveland, Ohio, where they met with the Ohio state campaign manager to map out their plans. Over the next few days, they traveled throughout Ohio, over rural country roads and through small villages, meeting farmers and holding impromptu speeches in village squares, attracting attention for suffrage everywhere they went. They visited the county fair at Meridian, Ohio, even receiving permission to let Suffragette trot a lap around the racetrack.

But they were not always received so cordially; Rosalie later remarked that Ohio farmers were sometimes "sour, colossal tightwads" who refused to let them or their horse rest on their property without a cash advance.[90] They returned home from Ohio feeling that they had made some difference but were disappointed to later learn that the Ohio suffrage amendment was defeated.[91]

Undeterred by the disappointment, Rosalie began planning for an even bigger event—a march from New York City to the state capital in Albany, where they would appeal to the newly elected governor William Sulzer to influence the legislature to add a woman suffrage amendment to the New York State Constitution. The march would begin in the Bronx and cover more than 140 miles; Rosalie planned it with such precision and such determination that her followers began to call her the "General." Her "second in command," Ida Craft, was dubbed the "Colonel," and their supply wagon was called their "commissary wagon." In this way, they imposed on themselves a real military persona and discipline that Rosalie felt was needed for such a daunting undertaking.

Not everyone thought that the march a good idea. Rosalie's mother, Mary Elizabeth Jones, was a staunch anti-suffragist and had tried to dissuade her daughter. "The idea is ridiculous," she asserted. "The trip is too long for any woman to make in cold weather. They will be exposing themselves to the snow, wind and ice and are jeopardizing their health. It is absolutely foolish."[92] She insisted that her daughter cancel her plans. Rosalie ignored her.

The march started on December 16, 1912, at end of the IRT subway line, at 242nd Street in the borough of the Bronx, with close to two hundred marchers taking part. The press was alerted, and other suffrage leaders, such as Harriet Burton Laidlaw from Port Washington, were in attendance for the grand sendoff. The marchers carried yellow backpacks and waved "Votes for Women" banners that fluttered in the cold December breeze. Some marched as far as the city of Yonkers and then dropped out; others joined them. The real hardship began when they left the New York City area and trudged up toward Albany. It was mid-December, and once the thrill of such

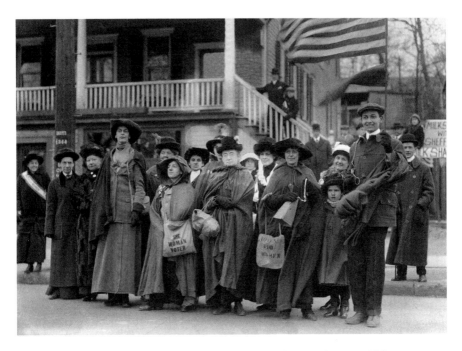

"General" Rosalie Gardiner Jones with her devoted marchers on the second hike to Albany, January 1914. *From left to right, front*: Eva Ward; Martha Klatschkin; Ida Craft, who accompanied Jones on many of her marches; Rosalie Jones; Serena Kearns; and Milton Wend. The first hike was in December 1912. *Courtesy of the Library of Congress.*

a daring project began to wane, the cold began to creep into their bones and sap some of their enthusiasm.

But all along the route, they found continued encouragement. In Upper Red Hook, New York, near the banks of the Hudson, three Rockefeller cousins joined the march for a short distance. Members of local suffrage organizations joined for a few miles, lending their support to the stalwart "army." Along the way, the group stopped to make impromptu speeches, garnering the attention of local newspapers, whose pages were filled with photographs and stories. The march took thirteen days and covered an amazing 170 miles. Along the way, the marchers camped overnight or stayed with sympathetic supporters. Weather conditions ranged from sunny and pleasant to bitterly cold. The marchers trudged on blistered feet through mud and rain. Ice crusted their banners and covered their hats and scarves but in no way diminished their enthusiasm. Asked once to make a speech to a local organization, Rosalie declined, stating, "We must press on." On Christmas Day, General Jones telegraphed the *New York Times* wishing "those who are fighting for the cause a very Merry Christmas."[93]

Only five of the original marchers were left as the group triumphantly entered Albany at 4:00 p.m. on December 28, 1912, where they were met by local suffrage leaders. According to the *History of Woman Suffrage*:

> *Whistles blew, bells rang, motor cars clanged their gongs, traffic paused, windows were thrown up, stores and shops were deserted while Albany gazed upon them and large numbers escorted them to the steps of the Capitol, where they lifted their cry "Votes for Women!"*

On December 31, they were finally received by Governor Sulzer, who promised his support, saying that he had already given "advice to the legislators to pass the suffrage measure." General Rosalie Jones declared, "We have done the thing we set out to do."[94]

But General Jones and her "army" did not rest on their laurels for very long. Buoyed by the success of the Albany march, they planned another, this time to Washington, D.C., to join the huge suffrage march planned for March 3, 1913. Rosalie Gardiner Jones and Elisabeth Freeman were not the only young women who were working to breathe new life into the American suffrage campaign. In Washington, D.C., a young Quaker woman, Alice Paul, and her friend Lucy Burns had also spent time in England and had seen firsthand the vigor of the British movement. They had moved to Washington, D.C., with the distinct goal of lobbying for the passage of a constitutional amendment granting women suffrage and were loosely sponsored by NAWSA. Their idea for a parade was to draw attention to the movement, as well as to draw attention *away* from President Wilson's inauguration, which was planned for the next day. (Presidential inaugurations were then held in March.)

Rosalie saw this as a perfect opportunity to bring the Long Island and New York State contingents to support the national branch of the movement. So, once again, "General" Jones marshaled her forces, and once again, they prepared for a long, cold march. They gathered at the Hudson Terminal, New York City, on February 12, 1913. This time, the marchers wore long brown woolen capes pinned with bright yellow badges demanding "Votes for Women." Rosalie stood on a bench and addressed the troops: "Remember, we are going through. Let those who fall out return, but remember, our motto is 'On to Washington.'" The group then boarded the train to Newark, New Jersey, where the official march began.[95]

This trip was even longer than the Albany hike—245 miles covered in fourteen days. As had happened on the New York march, along the route some dropped out and others took their place. Mayors of towns along the

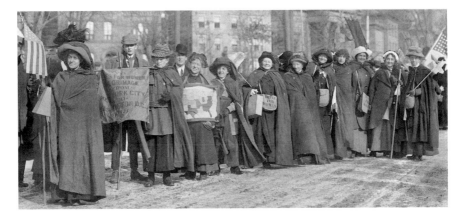

"General" Jones and her marchers hike to Washington, D.C., to take part in the March 3, 1913 parade on the eve of President Wilson's first inauguration. *Courtesy of the Library of Congress.*

way made speeches of welcome; in Philadelphia, crowds had waited for hours to welcome them and listen to their speeches. In university towns such as Princeton, students fell into rank, marching to the edge of towns, where others took up the challenge. Elisabeth Freeman drove her wagon, covered with suffrage slogans and pulled by her new horse, Laussanne. They marched through villages, where residents stood on the side of the roads and cheered. Some offered them refreshments; one woman ran out to greet them with dozens of hardboiled eggs. "Warm your hands with them," she advised, "and then eat them at the end of the day."[96]

This march was not without controversy—a group of African American women that wanted to join the marchers in Maryland was refused. Rosalie's motives for refusing to welcome the women are unclear, but the *New York Times* reported that she had been threatened by two men from the South: "If you advocate votes for negro women you will indeed find that your way to Washington lies through the enemy's country." "The men and women of those States must solve their own problems," Rosalie countered. But the African American women were still rebuffed, and the march continued to Washington without them.[97]

Finally, on February 28, the marchers arrived, bedraggled and cold, in Washington, D.C., where they were greeted by Alice Paul's Congressional Committee with flowers and tributes. Of the original hikers, only fourteen had made it all the way, but once again, "General" Jones had marshaled both forces and publicity, both badly needed to win the battle for suffrage. "Three cheers for General Jones!" shouted the crowd, and her mother, despite her anti-suffrage stance, smiled proudly.[98]

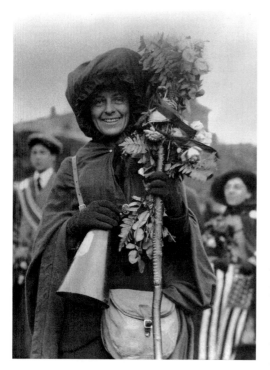

"General" Jones and her marchers in their triumphant entrance to Washington, D.C., March 1913. Even her anti-suffrage mother smiled and cheered. *Courtesy of the Library of Congress.*

On March 3, after a few days' rest, the New York group joined with Alice Paul, Lucy Burns and thousands of other suffragists as they marched through the streets of Washington, D.C., led by Inez Milholland on her white steed, carrying her trumpet that heralded the "free woman of the future." Marchers representing all occupations—lawyers, nurses, homemakers—carried hundreds of bright yellow flags and banners, all proclaiming their demands for the vote. There were ten bands, twenty-six floats and six golden chariots representing the first six suffrage states.[99]

As reported in other chapters, the March 3 parade became famous not just for the participation of thousands of women from all over the world but for the violence that erupted along the route. Marchers were brutally attacked, their banners ripped from their hands. Ropes stretched to keep back the crowds were broken, and the women were forced to march through an ever-narrowing lane, increasingly hemmed in by shouting, abusive spectators, while the Washington police stood by and watched, or worse, joined with the abusers. Rosalie and her New York contingent did not escape the fray—they were so hemmed in at one point that they were forced to ask a group of Maryland Agricultural college boys for assistance in opening up the lane for them. But they managed to work their way through to the end, where the Fifteenth Cavalry from nearby Fort Meyer finally came out to defend the marchers and lead them on to the U.S. Treasury building.[100]

The abuse of the marchers by both bystanders and police had an unexpected silver lining. The headlines in the next day's newspapers were sympathetic, with the *New York Tribune* claiming, "Capital Mobs Made

Converts to Suffrage," and the *New York Times* announcing, "5000 Women March Beset by Crowds." The abuse had actually helped them gain national attention and sympathy.

Rosalie returned to Long Island to continue her work for suffrage. In May 1913, she organized a march from Mineola down Franklin Avenue to the Hempstead Trolley junction, where marchers were met with speeches of welcome from local politicians and suffrage groups. The *New York Tribune* reported that there was a "Streak of Yellow" from Mineola to Hempstead, with more than five hundred marchers joining General Jones and some of those who had marched to Washington with her. The end of May found her literally up in the air, flying high above Staten Island in a two-seat Wright biplane, tossing out yellow "Votes for Women" leaflets from the air.[101]

After the amendment passed, Rosalie continued campaigning for social reform, even as she attended graduate school in Washington, D.C., receiving a doctor of civil law degree from American University in 1922. In 1927, she married a U.S. senator from Washington, Clarence C. Dill, in a ceremony from which she insisted the word "obey" be eliminated. When the marriage ended in divorce in 1936, she retained her maiden name and moved back to her family home in Cold Spring Harbor, where she bred goats and helped manage the family properties. She died in 1978 at the age of ninety-four.

Whenever the suffrage campaign on Long Island is mentioned, the name of "General" Rosalie Gardiner Jones is probably one of the first to be recalled. Rosalie was a maverick who paid scant attention to the social conventions that ruled the lives of others in her family. She braved their formidable disapproval to become a fierce advocate for equal rights and equal educational opportunities for both men and women. She left the luxury of her comfortable home to bring the suffrage movement where it had never gone before—into small Long Island villages and hamlets that were never visited by politicians, presenting a personal contact that was both impassioned and provocative. There is little doubt that those who met her on her flamboyant hikes would ever forget her and that the personal and vibrant communication she brought to her little corner of the suffrage movement is what ultimately helped to carry the entire movement on to victory.

She is a real Long Island heroine.

Chapter 7

EDNA BUCKMAN KEARNS

1882–1934

Woman suffrage is bound to come, and the sooner it comes the better for humanity.
—Edna Buckman Kearns

At first glance, the wagon looks a bit frail, certainly not able to carry several people over miles of bumpy Long Island roads, much less the burden of an entire social movement. Its wheels are fragile, its bed is weighted by time and its nickname, the "Spirit of 1776," is still lightly stenciled on its side, seemingly a touch ironic. It certainly shows it age—more than one hundred and fifty years. But neither age nor use have bowed or battered it; instead, it seems endowed with a special strength that will not fade.

Use of the automobile was just emerging in the early part of the twentieth century when this wagon saw its most active days. Thousands of horse-drawn wagons were still in use then, delivering goods, helping farmers with the harvest, carrying the mail and ferrying people about. But this wagon was different. It had a mission that endowed it with the extraordinary spirit of those seeking the simple freedom of political equality. It was altogether fitting that this wagon be dubbed the "Spirit of 1776," a time when our nation fought for political freedom from England. The women who rode in this wagon, who drove it up and down the dusty roads and country lanes of Long Island, were also seeking political freedom—the right of women to take full part in their own democracy. For this was, and still is, Edna Kearns's Suffrage Wagon.

Edna Buckman Kearns was born in Pennsylvania on December 25, 1882, to Charles Harper Buckman and May Phipps Begley; her brother, Thomas

Smith Buckman, was born in 1886. The Buckmans were Quakers (also known as members of the Religious Society of Friends), whose ancestors had arrived in 1682 with the new governor of Pennsylvania, William Penn, seeking freedom from religious persecution. The Quaker faith espouses a sacred respect for all living forms, conscientious objection to war and, especially, the equality of all men and women. The Buckman family's faith was evident in the lives they lived: the extended Buckman family acted as conductors in Pennsylvania on the Underground Railroad, helping slaves escape to freedom, and Edna's mother, May Begley Buckman, was active in the temperance movement.

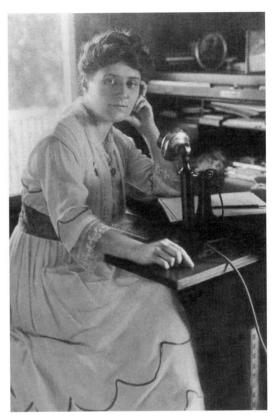

Portrait of Edna Buckman Kearns. *Courtesy of Marguerite Kearns, Suffrage Wagon News Channel, www. suffragewagon.org.*

Edna graduated from a Quaker school in Philadelphia, Pennsylvania. Her diary from that time shows an interest in attending art school, but instead, on June 8, 1904, she married Wilmer R. Kearns. The young couple moved to New York City, where Wilmer eventually became treasurer of his brother's business, the Kearns Motor Company. Their first daughter, Serena, was born on August 3, 1905.[102]

When Edna and Wilmer Kearns moved to New York City in 1904, the Progressive reform movement was in full swing. Waves of European immigrants were crowding the port of New York, tenements and schools. Disease was rampant and social services strained. Proponents of the reform movement felt it was their duty to help people better their lives, and to that end, politicians from both parties espoused opening health clinics

and passing protective legislation that outlawed child labor and provided safer and healthier working conditions in factories and sweatshops. But the Progressive movement exposed in stark relief the irony of women's inability to effect any change at all because they lacked the power of the vote. Instead, they had to depend on husbands, fathers and sons to promote what the men deemed was in society's best interests.

In vivid contrast to the active Progressive movement, the American woman suffrage movement was still in a desultory period in 1904; the last state to award women full enfranchisement had been Utah in 1896.[103] Soon after moving to New York, Edna began working in local and state suffrage campaigns. The family bought a summer home in Rockville Centre on Long Island, where Edna took the lead in local suffrage organizations, hosting meetings and organizing activities. She was endowed with strong writing skills and possessed an innate sense of the benefit of publicity for the suffrage cause. In addition to her work as a suffrage reporter and correspondent for numerous New York and Long Island newspapers, she worked as an editor at the *Brooklyn Daily Eagle*, where she was adept at using her position as editor to encourage other women to write and speak out about their need for the vote. But she knew that writing about suffrage alone wasn't enough—they had to personally go out and bring the message to the public themselves.

During the summer of 1912, the suffragists on Long Island executed an extensive "whirlwind" campaign across the length and breadth of the island. On July 3, they met at New York Suffrage Association State Headquarters in Manhattan, clambered aboard a borrowed touring car decorated with colorful suffrage flags and banners and set out to literally take Long Island by storm. From Borough Hall in Brooklyn to Jamaica, Queens and on to Flushing, the group traveled, stopping along the way at libraries and street corners, making speeches and selling flags, buttons and armbands, all bearing their message, "Votes for Women." On July 4, they moved on to the Long Beach boardwalk on the south shore, where Edna gathered the bathers on the beach together for an impromptu speech from the lifeguard's station, fielding questions and explaining their positions. Others moved on to Rockaway Beach, distributing leaflets and even organizing an impromptu parade down the beach. The trip was not easy; the heat was difficult for them to bear, but the suffragists were not averse to sacrificing personal comfort for the cause. As reported in the *New York Suffrage Newsletter* on August 1, 1912:

> *On Monday the dreadful heat increased. Three or four meetings a day were exhausting. But the interest everywhere manifested sustained our weary*

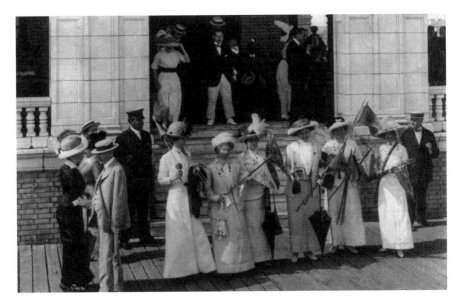

Suffragists in their Whirlwind Campaign of 1912 sell buttons and banners and enroll new members on the Long Beach boardwalk. *Courtesy of the Library of Congress.*

frames. We held twenty-five meetings during our campaign…Many parts of Long Island are remote from present activities and intensely conservative. But they show signs of awakening.

The caravan went on to Lynbrook and Rockville Centre, out to Amityville, Sayville, Bayport, East Hampton and back down along the north shore to Ida Bunce Sammis's home in Huntington and finally to Great Neck. All across the island, from Brooklyn to East Hampton, the suffragists brought their message personally to everyone who would listen, speaking from their hearts and imploring their fellow citizens to support political equality for all.[104]

Through all her suffrage activities Edna was supported by her mother, May Begley Buckman, and her husband, Wilmer; both joined her on marches and at rallies. But Edna's most enthusiastic supporter was probably her small daughter, Serena, whose presence reminded everyone that they were working not just for themselves but for the political freedom of future generations. Serena was a cheerful and enthusiastic six-year-old member of the 1912 team touring Long Island; reports described her "waving her *Votes for Women* pennant until her little arm was tired."[105]

In 1913, the New York State Suffrage Association was offered the gift of a historic horse-drawn wagon, dubbed the "Spirit of 1776." The wagon was

Serena Buckman Kearns proudly wears her "Votes for Women" sash. In her hand, she has articles and poems she has written supporting woman suffrage. *Courtesy of Marguerite Kearns, Suffrage Wagon News Channel, www. suffragewagon.org.*

donated by the I.S. Remson Company of Brooklyn. It was first believed that it had been built in the year 1776, thus truly representing the fight for freedom from tyranny and oppression. When further investigations revealed that it might have instead been built around 1820, the suffragists were undeterred—it still represented for them the spirit of their battle. After all, if taxation without representation was tyranny in 1776, why not in 1913? On July 1, 1913, the wagon took part in its first suffrage parade when it was presented to New York State Suffrage president Harriet May Mills and later given to Edna Kearns, who saw it as an eye-catching way to grab the public's attention.[106]

From that day on, the Suffrage Wagon assumed its mantle as a symbol of the suffragists' cause. It attracted large crowds and offered a perfect speakers' platform. With little Serena and other suffragists perched on the wagon's seat, Edna dressed in colonial clothing and drove the wagon in torchlight meetings, rallies and parades. From time to time, fellow suffragist Rosalie Gardiner Jones from Cold Spring Harbor drove her yellow wagon alongside the Suffrage Wagon and was joined by suffragists Elisabeth Freeman and Irene Corwin Davison. The paths of the active Long Island suffragists crossed and crossed again as they wove a vibrant web of activism across Long Island.

In another bid for publicity, Edna joined fellow suffragists in 1913 as they climbed aboard a small airplane, flying high above Long Island,

scattering leaflets with suffrage messages, showing that suffragists were ready for any challenge. And on November 3, 1914, in the midst of a howling gale, Edna joined seven other suffragists atop a scaffold at 110th Street and Amsterdam Avenue in New York City to paint a billboard advertising a suffrage meeting at Carnegie Hall. Not that she was unafraid: on November 3, 1914, the *New York Tribune* reported, "It was 3:45 when Miss Willis, Mrs. Watkins and Mrs. Kearns climbed the ladder to the scaffolding, and then…sat down on the narrow board and screamed. They recovered their poise, however, and proceeded to paint."

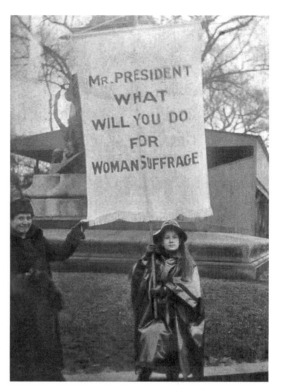

Serena joins her mother, Edna Buckman Kearns, and her father, Wilmer Kearns, in picketing the White House. *Courtesy of Marguerite Kearns, Suffrage Wagon News Channel, www.suffragewagon.org.*

Suffrage was always a family affair for the Kearnses. Serena was dubbed "Nassau's Youngest Suffragist" and wrote articles and stories herself for the newspapers.[107] The entire Kearns family marched in the parade in Hempstead, New York, on May 24, 1913, and later marched part of the way with Rosalie Gardiner Jones as she left for a hike to Albany in 1914, reprising her famous suffrage march of the previous year. Wilmer maintained his unwavering support. He marched in suffrage parades, including the famous one March 3, 1913, in Washington, D.C., braving ridicule for aligning himself with suffragists. He cared for Serena when Edna was away tending to suffrage work and handled the mail and scheduling of events. He was proud of her and her unswerving devotion to suffrage.

As a newspaper editor, Edna was ever vigilant for local stories about suffrage. She knew that the British suffragettes followed a more militant

program than their American counterparts. Frustrated by the lack of progress, it was not uncommon for British women to break windows and set houses afire. In August 1915, Edna learned that a film company was preparing to make a movie in the Rockville Centre area in support of an anti-suffrage campaign. Brazenly, they planned to burn down a house and blame it on the suffragists, even though American suffragists never indulged in such violent activities.

When Edna heard of the scheme, she hurried to the scene and "did her duty as she saw it." She made a speech to the hundred or so actors and producers on the movie set. "If they plan to ridicule suffrage," she said, "they are going to meet with unexpected opposition. Nassau County is the stronghold of suffrage and the opposing interests know it." The moviemakers eventually backed down, the house was spared and the suffrage movement was spared the libelous publicity.[108]

Edna was sometimes accused of being a "bad mother" since she often took Serena with her to parades and rallies. People shouted from the sidelines of a march, "You should be home taking care of your child," criticism Edna sorely resented. Serena loved being with her mother, and both Edna and Wilmer thought it was of utmost importance that she learn firsthand about the values for which her parents were fighting. Edna felt those who wondered if women could vote and still be good mothers were missing the point—it was precisely a mother's responsibility to vote for programs and legislation that would benefit her children. In an editorial for the *Brooklyn Daily Eagle*, she explained:

> *Politics does affect humanity. It affects the home and the children in the home. The pure food, weights and measures, air, light, tenements, safety from fire, police protection, taxation, sanitation, recreation, parks,...factories, offices, shops, all are controlled by politics...Many women are now beginning to see the connection between politics and the home. Suffragists are simply busy helping others to understand. They want their sex, equally with men, to be about their business; that is, to care for humanity.*[109]

Edna also took pains to demonstrate that suffragists could be excellent homemakers. In the summer of 1915, while making a rather ordinary speech on the benefits of suffrage, she happened to mention that that very day, before coming to make the speech, she had canned seventeen cans of peas and six cans of raspberries. Her listeners gathered around and bombarded her with questions about recipes and techniques, and in the course of the

afternoon, another twist to benefit suffrage emerged. Not only could Edna demonstrate that suffrage and housewifery were twin movements that could benefit each other, she had also found a way to raise funds for the cause. A teacher was engaged, and throughout the month of August, women traveled throughout Long Island giving demonstrations on the proper way to can food. In an article in the *Monroe County Mail* in Fairport, New York, Edna reported, "We are proving the fact that suffragists can can and can campaign while they can. Suffrage stands for the best way of being the best sort of woman in the home."

In 1915, the efforts of suffrage organizations in New York, Pennsylvania and New Jersey for the passage of an amendment to their respective state constitutions drew national attention. There were rallies, speeches, luncheons, concerts and a massive parade on Fifth Avenue in New York City that drew between twenty-five thousand and thirty thousand marchers. Despite these efforts, the measure was defeated in all three states.

Undeterred, the suffragists turned their attention to 1917. (Amendments to state constitutions can only be proposed every two years.) Alice Paul and her National Woman's Party (NWP) began their campaign of picketing the

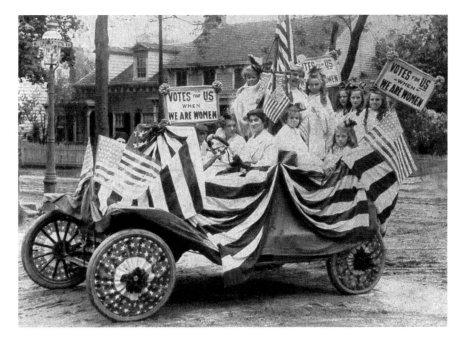

Suffragists pile into a gaily decorated car to carry the message. *Courtesy of Marguerite Kearns, Suffrage Wagon News Channel, www.suffragewagon.org.*

White House, bringing the protest directly to President Wilson's front door. Edna traveled to Washington with Serena (now twelve years old and totally committed to suffrage), and the two took their turn picketing at the White House gates. Edna continued to believe that it was important for Serena to become involved in these protests, to take some ownership of the movement that would hopefully change her life and the lives of other young girls. In 1917, when New York women were finally granted the right to vote, attention turned to securing an amendment to the U.S. Constitution.

One of Edna's last suffrage demonstrations occurred on March 5, 1919, in New York City during a visit of President Wilson to the Metropolitan Opera House in a march led by Alice Paul and Doris Stevens of NWP. The goal was to catch Wilson's attention when he entered the opera house, and to this end, the women carried banners asking the same familiar questions: "Mr. Wilson, What Will You Do for Woman Suffrage?" and "Mr. President, How Long Must Women Wait for Liberty?" Newspaper accounts of the demonstration were grossly exaggerated, describing the marchers as "two hundred maddened suffragists" who fought with police and "used the poles of their banners as staves, breaking them on the heads of the policemen." Edna's account of the incident was entirely different; she noted on a copy of the news article that there were only thirty-six marchers and that the women were actually attacked by contingents of soldiers and sailors that had gathered to "help" the police control the crowd. Six women were arrested but very quickly and "mysteriously" released. Still, the women's message was clear—they were not going to give up.[110]

In 1920, when the Nineteenth Amendment to the Constitution became the law of the land, credit is almost always given to the more famous activists—Susan B. Anthony, Elizabeth Cady Stanton and Alice Paul—women who worked in a very conspicuous national spotlight. But equal credit should be paid to the unsung heroines such as Edna Buckman Kearns, who toiled for years at the local level, with little attention paid to their efforts. Working through local women's clubs, temperance societies and community organizations, they illustrated perfectly the strengths of a grass-roots campaign, waging the battle literally from the ground up to affect change in an efficient, organized, nonviolent effort that the nation had never seen before.

Edna was not just an excellent writer, but she was also a gifted communicator who learned to use all the tools at her disposal. While her gift for the written word was exhibited through her newspaper work, she also knew the value of a personal, face-to-face appeal. She made speeches,

Edna Buckman Kearns's Suffrage Wagon on display in the capital at Albany, New York, 2010. *Courtesy of Marguerite Kearns, Suffrage Wagon News Channel, www.suffragewagon.org.*

caught the public's attention through stunts and marches, lobbied public officials, knocked on doors and sold suffrage memorabilia. No avenue was left unexplored in her sincere and unwavering belief that her goal was a worthy one. Proof that Edna embodied the soul of the movement came from leader Alice Paul, who remarked that all the movement needed for success was one Edna Kearns in every district.

As the nation's women enjoyed the thrill of their first vote, Edna and her family shared their own personal joy when on November 12, 1920, she gave birth to her second daughter, Wilma. The family moved back to Pennsylvania, where, in keeping with her Quaker faith, she remained active in social issues, as well as operated a flower nursery business. She died in 1934.

Today, the history of the suffrage movement remains alive and is enriched by the substantial work of her granddaughter, Marguerite Kearns, who maintains an ambitious online archive of her grandmother's work (see the Suffrage Wagon News Channel, www.suffragewagon.org). The "Spirit of 1776," the wagon that figured so prominently in the woman suffrage movement, was generously donated by Marguerite and her family to the State of New York. In 2010, it was exhibited in the lobby of the New York State Capitol. It is hoped that New York State will mount future exhibits of the wonderful symbol that continues to remind us of the valiant spirit of a woman who would not cease her efforts until political equality was secured for all.

Chapter 8

HARRIET BURTON LAIDLAW

1873–1949

We do not wish to stop, ever.

—Harriet Burton Laidlaw

T he Colonel's not coming.

This unsettling news reverberated throughout the lines of sashed marchers and down the rows of hundreds of eager spectators who lined the parade route out into the cool night air. It was November 9, 1912, and former president Theodore Roosevelt, who had been invited to march in the suffragist torchlight parade, had been shot in the chest a few weeks earlier in Milwaukee while campaigning for the presidency on the Bull Moose ticket. He was expected to recover but would be unable to attend the parade. Instead, the Bull Moose Party would be represented by a small contingent of marchers.[111]

As chairman of the parade, Harriet Burton Laidlaw must have been both relieved and upset—relieved that the former president would recover and upset that her plans to have him make public his support for the suffrage cause were in tatters. In 1912, the Bull Moose Party was the only political party that had a plank supporting woman suffrage. His presence would have given their cause a much-needed boost. Well, they would simply have to go on without him. She picked up her pumpkin-shaped lantern glowing brightly in the cool night air and resolutely led her contingent of more than twenty thousand marchers down Fifth Avenue, where history was waiting.

Harriet Burton Laidlaw was no stranger to disappointment. Much of her adult life had been spent working to secure for women the right to

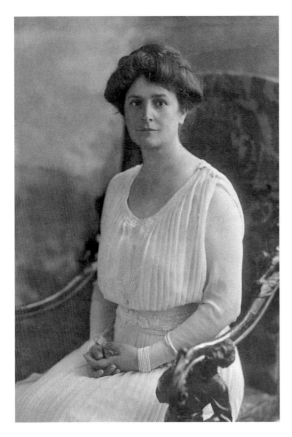

Portrait of Harriet Burton Laidlaw. *Courtesy of the Sophia Smith Collection, Smith College.*

vote, and still it eluded them. But Harriet was never one to give in to disappointment or discouragement. From her earliest years, she had held the unwavering belief that simple justice demanded women have equal rights with men, and she was willing to work tirelessly to achieve that goal. She made her first public speech proposing equal suffrage in 1893, at the age of twenty in the drawing room of a friend, to an audience of cousins, aunts and friends. In later years, she would make much the same speech on stages and soapboxes, in elegant parlors and on rough city street corners to much larger crowds, first in the hundreds, then in the thousands—some listeners would not always be as accepting and polite.

The next year found the capital city of Albany, New York, abuzz preparing for the Constitutional Convention to be held May 8, 1894. Since New York State's last Constitutional Convention in 1867, the woman suffrage movement had grown both in size and fervor, and suffragists felt that they now had the strength to demand an amendment to the state constitution striking the word "male" in the list of qualifications for voters, thus leaving no sex discrimination and opening the door for women to vote. Prominent leaders including Susan B. Anthony and Carrie Chapman Catt descended on Albany, making speeches, holding rallies and securing more than 600,000 signatures on a petition. The speakers reminded the legislators that "the tramp who begs

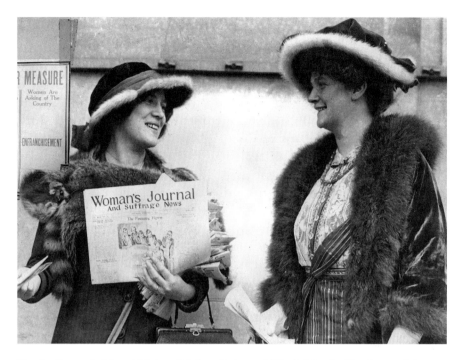

Harriet Burton Laidlaw (right) and Esther Abelson of Rhode Island selling issues of the *Woman's Journal. Courtesy of Bryn Mawr College Special Collections.*

cold victuals in the kitchen may vote; the heiress who feeds him and endows a university cannot."[112] But their pleas fell mostly on deaf ears. The bill was defeated, ninety-eight votes to fifty-eight.[113]

Harriet worked as a page at the convention, distributing literature and listening to the speeches of those who were undoubtedly her heroines. Throughout the years that followed, as she attended college and went on to become a teacher, she never forgot those tumultuous days in Albany. They informed her entire life—the career choices she would make, the friends she would ultimately choose and even her choice of spouse. But in that Albany parlor in 1893, when she made that first speech, she could not possibly have known that she herself would play a leading role in securing equal rights for millions of women, both then and for generations to come.

Harriet was born on December 16, 1873, in Albany, New York, to George Davidson Burton and Alice Davenport Wright Burton, the oldest of three children and only daughter. While little is known of her mother's ancestry, her father claimed descendants from Scottish, English and Dutch ancestors. In 1879, when George Davidson Burton died, Harriet's mother took the

children to live with his parents. Despite their reduced circumstances, her family must have been supportive, for Harriet developed the self-confidence to speak her mind and forge her own identity. She attended what was then Albany Normal School (which later became the New York State College for Teachers), receiving both bachelor's and master's degrees in pedagogy (the science of teaching), and she continued to study for the next several years, receiving degrees from Barnard College, Illinois Wesleyan University and Columbia University, as well as taking courses at Harvard and the University of Chicago.[114]

For a young woman to follow such an intense program of study was unusual for the time, for while many young women were postponing marriage and going to college, the actual number who did so was small—in 1900, they represented about only 2.8 percent of the population.[115] Even more daring, Harriet lived on her own and taught in the public schools in New York City for the next twelve years. But although she broke with tradition to attend college and live on her own, she hewed to the conventional path when in 1905 she left her teaching career behind to become the wife of banker James Lees Laidlaw.

James Lees Laidlaw's family had descended from the earliest settlers of the nation; at the age of eighteen, he left school to work in the family's banking firm that his father had founded before the Civil War. The couple's first date was at charity ball, and it was reported that they "danced until the last strains of 'Home Sweet Home' floated across the floor." They were married the following year, and the year after that, their first and only child, Louise Burton Laidlaw, was born.

For some young women in the early twentieth century, marriage might have curtailed their attention to interests that threatened to take them from their homes and families, but for Harriet, marriage to James Lees Laidlaw proved to be the most freeing move she could have made. James was an unusual spouse for the time; his interest in the cause of woman suffrage matched her own, and together they would spend their married years working toward the common goal of equal rights for all. In 1910, James was elected president of the Men's League for Woman Suffrage, a post he held until 1920.

Harriet formally dipped her toe into the activists' field in 1908, when she served as the secretary of the College Equal Suffrage League (CESL) in New York City. The CESL had been founded in 1900 by suffragists Maud Wood Park and Inez Haynes to involve young female college graduates in the work of promoting suffrage. Both graduates of Radcliff College, Maud Wood

Harriet Burton Laidlaw (left) and Mrs. W.B. Morgan selling flowers to benefit suffrage in New York City. *Courtesy of Bryn Mawr College Special Collections.*

Park and Inez Haynes were active in the Massachusetts Suffrage Association. Ms. Park was particularly impressed by the many years of hard work that had been invested by the early pioneers of the movement, work that had virtually paved the way for the younger women to attend college, receive advanced degrees and enter professions that had been heretofore closed to them. They were convinced that the only proper way for college-educated women to repay this debt was to take up the suffrage cause:

> *The time has gone by when a college woman can be allowed to be noncommittal on this subject. If she has not thought about equal suffrage she must do so now, just as those of intelligence were compelled to think about slavery in the time of Garrison, or about the reformation in the time of Martin Luther.*[116]

Chapters of the CESL began to open throughout the country; the first one was in New York, with Harriet as secretary. In 1908, the league officially joined with the National American Woman Suffrage Association (NAWSA), and it was a natural progression for Harriet to begin to then take an active role in NAWSA.

On October 29, 1909, the Woman Suffrage Party of Greater New York was launched by Carrie Chapman Catt, one of the leaders who had spoken at the Constitutional Convention in Albany in 1894. Catt was a skilled organizer who realized that in order to succeed, the movement must approach this political question from a political angle, working within the existing political structure. She appointed a leader for each of the 63 assembly districts of the city and a captain for each of the 2,127 election districts. These leaders would be supervised by a borough chairman and, above her, a city chairman.[117] The strategy was to develop an efficient way to identify, contact and thus influence every elected official in the city.

To achieve this, Catt knew that she needed skilled volunteers who would work methodically but aggressively. Harriet may have come to her attention through her work in NAWSA and the CESL. Catt saw in Harriet a woman who, besides her devotion to suffrage, was personally likeable, friendly and outgoing. Additionally, Harriet had little tolerance for women who opposed voting rights for women, calling them "ultra society women."[118] She was perfect for the job of Manhattan Borough president, a position that she accepted in 1911.

As the campaign for woman suffrage grew, leaders began the unusual practice of using parades for public demonstration, very much aware of

the power of a parade to invite the public's attention. At first, it was an uncommon sight—thousands of women breaking from their traditional private roles to march openly down the street, some pushing babies in prams. Bands played, flags waved and the movement for woman suffrage was at once and forever transported from the private and sedate world of front parlors and women's club meetings to the very public sphere of the street. The first formal suffrage parade was held in 1910; they were held regularly from then on.

Both Harriet and James took active roles in the suffrage parades. In the 1910 parade, James cheerfully joined eighty-six other men, all members of the Men's League for Woman Suffrage, in a march up Fifth Avenue, to the jeers of many bystanders. Acting as chairman for the Torchlight Parade on November 9, 1912, was an important turning point for Harriet, one that swept her from a soldier in the army of suffrage workers to one of the leaders. The *New York Times* reported that the parade was watched by 400,000 to 500,000 people, lining Fifth Avenue in Manhattan from Fifty-ninth Street to Fourteenth Street. Floats representing six states that had already granted woman suffrage (Wyoming, Idaho, Utah, Colorado, Washington and California) were led by floats from four states that had recently done so (Arizona, Kansas, Michigan and Oregon). On November 10, the *New York Times* reported:

> *It was a line, miles long of well-dressed, intelligent women, deeply concerned in the cause they are fighting for; of girls in their teens, overflowing with enthusiastic exuberance, and of men, the majority young, husky fellows who…carried high the yellow pennants of the cause and the big, yellow, pumpkin-shaped lanterns that more than anything else made last night's parade a thing beautiful to look upon…The picture was that of a long river of fire, ending in a blazing display…in Union Square.*

In 1913, Harriet and James traveled to support the cause of suffrage in the western states, helping to organize a Men's Equal Suffrage League chapter in Montana. Success in the western states was crucial to the ultimate goal of a federal amendment, as voting women there could be called on to elect legislators in their states who were sympathetic to the suffrage cause. In addition to her work of public speaking and political organizing, Harriet was a prolific writer. She wrote eloquent letters to politicians and officeholders and to the editors of newspapers, persuasive columns and articles describing how important it was for women to have the vote so they could achieve

Young girls selling flowers for suffrage at the Long Island parade, 1913. *Courtesy of the Library of Congress.*

needed reforms. Of most importance to the work of the suffragist was the booklet she wrote in 1914 and published by NAWSA, *Organizing to Win: The Political District Plan, a Handbook for Working Suffragists.*

Organizing to Win sought to educate the suffragist worker on the actual workings of the political process and then on systematic methods for ensuring that they "focus all the existing suffrage work directly upon these political representatives of the people to the end that they may be induced to work for the suffrage bill once it has been introduced in to the Legislature." District leaders were to become acquainted with the political party leaders in their district. Neighborhood meetings, house-to-house canvassing and public rallies were to be combined with fundraising—tearoom sales, dog shows and even suffrage sleigh rides— all leading to a "well-built, orderly, persistent" program of activities that voiced an "undeviating demand for the submission of the woman suffrage amendment to the voters." Of all of her activities and writings, *Organizing to Win* was the most influential and powerful contribution that Harriet could have made to the movement, as it outlined in meticulous detail the path that was eventually followed to victory.[119]

But it was not all hard work. At Hazeldean, their Sands Point Long Island estate, Harriet and James hosted tea parties on the lawn and attended benefit balls. They toured the island in their car, helping to organized local suffrage leagues, and took part in local Long Island parades. They even enlisted their

young daughter, Louise, in the movement. In an interview with a reporter from the *Long Island Press* in October 1964, young Louise remembered:

> *I'd be in the back seat of our big open Pierce Arrow with a big pile of women suffragist leaflets to distribute along the way. Mother taught me how to aim them to fall right at the farmers' feet and not litter up the countryside. It was great fun for Mother and me but Father didn't fare so well. When he and the other men marched with suffragist banners the boos and catcalls were the loudest.*[120]

By 1915, Harriet and other suffrage leaders were convinced that the New York State legislature would finally pass a woman suffrage amendment. They began their campaign in January with a decision to canvass all of the 661,164 registered voters in the state. According to the *History of Woman Suffrage* by Susan B. Anthony and Ida Husted Harper:

> *Hundreds of women spent long hours toiling up and down tenement stairs, going from shop to shop, visiting factories, big department stores, covering rural districts, and immense office buildings with their thousand of occupants…60% of enrolled voters received personal appeals. The membership of the party was increased by 60,535 women secured as members by canvassers.*

Women made "suffrage raids" on banks, where they gave out literature to depositors, on firemen in their firehouses, on barbers as they cut hair and on workers in excavation sites as they dug in the earth. No one was immune to their entreaties as they distributed flyers, sang songs and in general called as much attention as possible to the woman suffrage cause. As vice-chairman of the New York State Woman Suffrage Party, Harriet was busier than ever, traveling throughout the state, making speeches from the back of her car and attending parades and rallies.

On the night of November 2, 1915, leaders, workers and officers gathered at suffrage headquarters to hear the sad news that they had lost the measure in New York State. But rather than deter them, their disappointment spurred them on to greater effort. Two days later, the New York City Party united with the national association to begin the next campaign to try again in 1917. The spirit of the members was high; they had learned some valuable lessons, had attracted many new members and had developed aggressive methods of raising much-needed funds.

Long Island suffrage leaders seek the support of President Theodore Roosevelt at a visit to Sagamore Hill, Oyster Bay. *From left to right:* Mrs. Ogden Reid, Mrs. Whitehouse, President Roosevelt and Harriet Burton Laidlaw. *Courtesy of Bryn Mawr College Special Collections.*

In 1917, Harriet became a director of NAWSA and met with former president Theodore Roosevelt and other suffrage leaders at his home at Sagamore Hill in Oyster Bay to try to again enlist his support for the suffrage cause. By then, the tide of public opinion had finally swung in the suffragists' favor. The amendment to the constitution of the State of New York was passed on November 6, 1917. NAWSA could now focus on Congress passing the federal amendment, which took place on in 1919 and was ratified August 26, 1920.

After winning the fight for woman suffrage, Harriet took no time to rest on her laurels but instead turned her attention to other humanitarian issues. She had long been active in the movement to abolish the white slave traffic, and she and James put their prodigious energies into promoting international understanding through the formation of the League of Nations. After James died in May 1932, Harriet remained active in the United Nations and various other causes until her death in 1949.

Harriet Burton Laidlaw was said to be a lovely, gracious woman whose beauty was matched by courage and action in the many challenges she undertook. From her early years, she devoted her life to the pursuit of peace and equal justice for all. Although she had many other interests, she spent most of her years and energy fighting for woman suffrage on Long Island and in the New York area.

On March 25, 1931, in Washington, D.C., the League of Women Voters unveiled bronze tablets honoring those who had worked for the suffrage cause, both on national and state levels. Harriet was listed among the sixty-seven names of honor on the New York State roll. Most fittingly, the tablets listed the name of only one man: James Lees Laidlaw.[121] Together they had fought and together they had won an important battle that would improve the lives of American women for years to come.

In October 1964, their daughter, Louise (then Mrs. Dana C. Backus), and her family donated a banner once owned by the Manhattan Woman Suffrage Party to the Port Washington Public Library, where it still hangs in the Reference Department. The banner's message is from a poem by George Eliot, "The Choir Invisible": "In deeds of daring rectitude, in scorn for miserable aims that end with self."[122]

Chapter 9

KATHERINE DUER MACKAY

1878–1930

It's coming, as sure as fate.

—*Katherine Duer Mackay*

The air was tense at the elegant Delmonico's restaurant in New York City that bright September morning in 1909. Hundreds of well-dressed women gathered to honor Anna Howard Shaw, president of National American Woman Suffrage Association (NAWSA). The luncheon was organized by Alva Vanderbilt Belmont, the wealthy, charismatic and sometimes controversial founder of the Political Equality Association and the National Women's Suffrage Union. For months, there had been gossip that she was feuding for power with Katherine Duer Mackay, founder and president of the Equal Franchise Society, and although the beautiful and equally charismatic Mrs. Mackay had been invited to the luncheon, it was rumored that she would not attend. The crowd was abuzz with anticipation.

Although it might be difficult to understand today, in 1909, declining such an invitation would be an enormous insult to Mrs. Belmont, who was extremely influential in political circles. The September 16 issues of both the *New York Evening Sun* and the *Evening Journal* carried exhaustive accounts of the luncheon, including a detailed description of the gowns worn, the entire menu of the luncheon (poulét grille, salade de laitue, glace vanilla) and the names of more than two hundred attendees, all members of various woman suffrage groups. But both newspapers also mentioned the anxiety concerning a simple question: will Mrs. Mackay attend, or will she reinforce

the rumors that she and Alva were irreconcilable enemies, and what harm would such enmity do to the progress of the woman suffrage movement?

The women need not have worried. Just as the guests were being seated, two large baskets of American Beauty roses were delivered, one for Mrs. Belmont and the other for Mrs. Shaw, with a card from Mrs. Mackay. And following them fifteen minutes later was Mrs. Mackay herself, elegant, beautifully dressed and begging to be forgiven for being late. The attendees applauded, the crisis was over and the women could breathe a sigh of relief and get on with the important work of their crusade.

When Harriot Stanton Blatch began courting wealthy women to join the suffrage cause, Katherine Duer Mackay was one of the first she approached. Not only was Katherine affluent and held a position of social prominence, she was also strikingly beautiful. She combined a fire for equal

Portrait of Katherine Duer Mackay. *Courtesy of the Bryant Library Local History Collection, Roslyn, New York.*

rights for women with a modest elegance that Blatch found appealing. As far as Harriot Stanton Blatch was concerned, Katherine Duer Mackay was the perfect suffragist to charm the wealthy and influential people Harriot felt were so important to the cause.

Katherine Duer was born in New York City in 1878 to William A. Duer and Ellen Travers Duer. Both families claim descendants from historic illustrious

American families: William A. Duer was a descendant from a delegate to the Constitutional Convention, and Ellen Travers Duer was a granddaughter of Reverdy Johnson, a distinguished senator from Maryland who had served as attorney general under President Zachary Taylor.[123] Although little is known of Katherine's childhood, it was probably much the same as many other wealthy young girls. She was educated at home, debuted into society in 1896 and was married in 1898 to Clarence Hungerford Mackay, whom she had met on a steamship crossing from England in 1897.

Clarence Mackay, born in 1874 in San Francisco, was the son of Mary Louise Hungerford and John William Mackay, who was one of the first to discover the Comstock silver mining lode in what was then the Utah territory. The Comstock Lode became one the most important mining discoveries in United States history, and John Mackay became unbelievably wealthy from his investments in the mines, establishing in 1874 the Postal Telegraph and Cable Corporation, which Clarence worked for and would later head. When the young couple married, the senior Mackays presented them with property in Roslyn as a wedding present, situated on the second-highest spot on Long Island with stunning views of Hempstead Harbor. The couple built their home there and called it Harbor Hill. Harbor Hill was designed by Stanford White, of the architectural firm of McKim, Mead and White, and was said to be the largest home Mr. White ever designed.[124]

The Mackays kept an apartment in New York City but established Harbor Hill as their main residence. After the birth of two daughters, Katherine became active in local social and philanthropic causes. But she took her activism a step further than most of her peers when in 1905 she became the first woman to run for a seat on the Roslyn School Board. The Mackays' philanthropy was appreciated in the community, and Katherine won the election in a landslide, holding her seat until 1910. Her husband must have approved of her running for the position, for he drove down from Saratoga, New York, on the day of the election just so he could vote for her.[125] In 1907, they welcomed their third child, a son.

The following year, Katherine joined the campaign for woman suffrage. Her approach to winning the vote for women was to be different than others—she preferred a more "ladylike" style, one that attempted to win favor and support by bringing the suffrage campaign into the drawing rooms of wealthy and politically influential men and women. She deplored the violent tactics of the British suffragettes and was convinced that she could make the woman suffrage movement more genteel in nature.

Unhappy with many of the already established suffrage organizations,

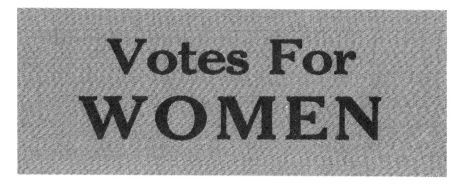

A suffrage banner. *Courtesy of the Suffrage First Media Project, author's collection.*

Katherine decided to create her own. She incorporated the Equal Franchise Society (EFS) in 1908 with herself as president. The first meeting was held at the Mackay home at 224 Madison Avenue. Its constitution stated in part: "The particular object and purpose of such society shall be to secure the national, state, and local electoral franchise for women." Although it sought to organize men and women in the "ranks of society," it also sought to involve "self-supporting" members who, it was believed, would benefit more than anyone by the ballot and whose support was deemed absolutely necessary. The annual dues had been set at five dollars and were later lowered to two dollars " in order to make it possible for self-supporting women to become members."[126]

Katherine also believed that the instincts of motherhood contributed to women's need for the vote. In an interview in *Munsey's Magazine* in 1909, she shared her feelings: "If women ask for suffrage it is because the mother of a family, more even than the father, will anxiously consider what sort of men shall be put in office to make and enforce the laws under which their sons and daughters are going to live. As I have often said, it is impossible for the half to express the whole."

Katherine Duer Mackay brought great flair and style to the suffrage movement. She was intimately acquainted with all the reigning leaders of New York society. The EFS opened its offices in lavish quarters at Madison Square in the tower of the Metropolitan building. Perhaps in order to make wealthy women feel comfortable, the room was decorated to resemble the drawing room in a French chateau. As funds for suffrage began to flow from the purses of the wealthy, secretaries were hired; Katherine's office employed three women to publicize its activities.[127]

Such involvement of prominent women was viewed as a bonus to other

suffragists who for years had sometimes been looked on in an unflattering light. No one could accuse Katherine Duer Mackay of being a "frumpy, unwomanly suffragist," as many of the others had been called. But Katherine was not naïve about her power to command attention and used it to further her own ends. Reporters often came to meetings to feature articles about her clothes and left with carefully prepared summaries of suffrage arguments.

Katherine believed that the education of young people, both men and women, about suffrage was of utmost importance, since the more they knew about suffrage, the more they would be convinced of its value in their personal lives. She established a series of lectures, held at the Garden Theater in New York, some even given by anti-suffragists.[128] Katherine never relented on her disapproval of the militancy exhibited by British suffragettes and other groups in the United States that might adopt their tactics. In October 1909, her remarks were reported in the *Constitution* in Atlanta, Georgia:

> *We feel that in order to secure the enfranchisement of women it is not necessary for us to imitate methods which are being used in other countries. American manhood has always treated American womanhood in such a way as to make us feel that we shall ultimately achieve our aim without sensationalism. The Equal Franchise Society will not endorse the militant methods.*

Consequently, when in October 1909 Harriot Stanton Blatch sponsored a U.S. visit of Emmeline Pankhurst, the leader of the militant British suffragettes, Katherine refused to introduce Mrs. Pankhurst at a rally at Carnegie Hall arranged by Blatch and even refused to attend. The EFS was the only organization not represented at the rally, where Mrs. Pankhurst spoke to an overflow crowd. Katherine insisted that she would give no countenance, direct or indirect, to the infraction of law and order. "I do not think it will be necessary in the future for us to go out into street corners, and shriek our propaganda at the passersby. We have but to plead our cause without raising our voice to those men and women who are not willfully ignorant of what woman suffrage should mean."[129] Blatch disagreed with her, but despite their differences, the two women remained good friends.

In January 1910, Katherine used her standing in society to win an audience with Governor Hughes of New York. She traveled to Albany to formally request an amendment to the state constitution allowing women to vote in New York State. Although she was received cordially and granted

a private meeting with the governor, the measure was ultimately defeated.

In May 1911, the EFS joined with other suffragists in a massive parade down Fifth Avenue, proudly waving their banners to the sounds of a fife and drum band and Scottish pipers. Katherine's organization was growing. It had begun in December 1908 with 16 members; by 1911, its numbers had grown to 678.[130] Other chapters had opened in the New York region, while across the nation, chapters were opening in Texas, Nevada and Montana. Suffrage was becoming more acceptable, and the scent of victory was in the air.

And then, almost in an instant, Katherine Duer

Mrs. Emmeline Pankhurst on a visit to the United States. Lucy Burns is on the left. Katherine Duer Mackay refused to meet with her or attend her speech. *Courtesy of the Library of Congress.*

Mackay's star began to fall. Rumors began to circulate of an affair between Katherine and her husband's doctor, Joseph Blake. In April 1911, she stunned the board of the EFS by resigning as president, stating that "my plans for the immediate future are so uncertain that it is not possible for me to commit myself to the necessary engagements." For the good of the society, she would resign, although she would stay on the board and maintain an interest in its activities.

Further shocks would follow, and the newspapers would cover it all. Without her knowledge, Clarence took the children to Europe to avoid being served divorce papers. The *New York World* reported that Katherine was sued by Dr. Blake's wife for $1 million, charging alienation of affection. (The suit was later dropped.) Katherine moved to Maine and later to Paris. The *New York Times* reported that the couple's divorce was granted in February 1914, with Clarence winning custody of the three children and Katherine granted visitation rights. Confirming suspicions, Katherine married Dr. Blake in Paris of that year, but that marriage also ended in divorce. She returned to New York in 1930, where she unsuccessfully attempted to reunite with

Clarence. She died of cancer that year.

Like a shooting star in the suffrage firmament, Katherine Duer Mackay rose suddenly and fell just as quickly, and the resulting scandal deflected some attention from her achievements. But despite the short span of her involvement, her contributions should not be discounted. Her beauty, wealth and enthusiasm encouraged other wealthy women to follow her lead and become involved. Under her patronage, working for woman suffrage became acceptable, even fashionable. Even her quasi-feud with Alva Belmont brought needed publicity and funds to continue the battle. And despite the fact that she was no longer in the front lines, she still believed that women should have the vote, if only to improve the world:

> *There are schools which educate the children of the women of today, and these need constant care. There are the injustice and oppression suffered by those women who have to make a living for themselves. There are hospitals to be worked for and there are public charities to be improved. Here is work enough for women to last them for a generation, and it is just the sort of work which women can do best.*[131]

Chapter 10

THEODORE ROOSEVELT

1858–1919

I have always favored allowing women to vote, but I will say frankly, that I do not attach much importance to it.
—Theodore Roosevelt, 1898

I emphatically do not believe that between men and women there ever can be identity of function, but this has nothing to do with giving them equality of right. They are entitled to this, and they ought to have it.
—Theodore Roosevelt, 1915

To the rest of the nation, Theodore Roosevelt may have been the dashing, colorful twenty-sixth president of the United States who charged up San Juan Hill, promoted conservation of the environment and brokered a deal that ended the Russo-Japanese War in 1905 (for which he won the Nobel Peace Prize in 1906). To Long Islanders, he is all of that, but in addition, he is now and always will be nothing less than a beloved favorite son. Although much of his colorful and exciting life was spent on an international and very public stage, it was to Long Island that he returned to enjoy his private life. Here he spent his most precious moments, built his home, raised his children, received foreign dignitaries, hiked, swam, lived and died. Here he is buried, with his wife, Edith, in a modest grave on a hillside near his beloved home of Sagamore Hill in Oyster Bay.[132]

Theodore Roosevelt's life and the lives of his family are deeply woven into the fabric of Long Island, so it would have been natural that his ideas and

First Lady Edith Kermit Roosevelt. *Courtesy of the Library of Congress.*

feelings about woman suffrage would be of immense interest to suffrage leaders of the island. The movement was experiencing some immense challenges during his presidency (1901–9), and with the president of the United States often in residence "right down the road," Long Island suffrage leaders such as Harriet Burton Laidlaw could not resist asking for his help, and they turned to him often, knowing that his support would be crucial to their cause.

At first, they were disappointed. Never a misogynist, Theodore Roosevelt had from his youth a deep respect for women, especially married women and mothers. In his senior thesis at Harvard, he wrote favorably about gender equality, even proposing that women keep their own names in marriage.[133] But on the subject of voting rights for women, he was decidedly noncommittal. In 1898, he told Susan B. Anthony that suffrage was "not very important." When she wrote to him again in 1904, imploring him to recommend to Congress the submission of an amendment enfranchising women, she received only a formal reply from his secretary. By 1908, his opinion still hadn't changed. In a letter to Mrs. Harriet Taylor Upton, treasurer of the National American Woman Suffrage Association, he declared:

> *Personally I believe in woman suffrage but I am not an enthusiastic advocate of it because I do not regard it as a very important matter. I am unable to see that there has been any special improvement in the position of women in those States in the West that have adopted woman suffrage, as compared with those States adjoining them that have not adopted it. I do not think that giving the women suffrage will produce any marked improvement in the condition of women.[134]*

Father addressing the woman suffragists

umbrella · sympathizer with militancy · lady with genteel figure · nothing but ice water

"Father Addressing Woman Suffragists." Cartoon drawn by President Roosevelt in a letter to daughter Ethel illustrating his distaste for making speeches to suffragists. *Image MS Am 1541.2, courtesy of the Theodore Roosevelt Collection, Houghton Library, Harvard University.*

Even as late as 1913, while he was beginning to speak more favorably about the measure, he remarked in a letter to his daughter Ethel how much he hated making speeches to suffragists and enclosed a cartoon entitled "Father Addressing the Woman Suffragists," with unflattering images of three women in the audience.[135]

It is his wife, Edith Kermit Roosevelt, whose feelings were truly enigmatic. While she seemed noncommittal on the subject, in 1904, she hosted a reception at the White House for more than three hundred women from the National American Woman Suffrage Association.[136] Roosevelt's sister, Anna (Bamie) Roosevelt Cowles, on the other hand, was an outspoken and dedicated anti-suffragist. Bamie felt that the suffragists' style was "frumpy" and their arguments unsound,[137] and she was not afraid to say so. She dismissed suffrage as unnecessary for women and preferred to influence politics from behind the scenes, which she could only do because of the family's political and financial position.

While Roosevelt could be headstrong and emotional, Edith was more controlled and private. But while she seemed on the surface to be reserved, she was in reality very politically astute, often more so than her husband, and he often depended on her innate political wisdom. Roosevelt often said that

whenever he went against his wife's advice, he did so at his own peril. These women and many like them simply did not see the urgent need for suffrage. After all, they were already politically powerful through their families and friends and financially secure without it. Perhaps the president maintained his neutrality on suffrage for the simple reason that his sister and perhaps his wife did not approve of it. This would explain his noncommittal stance during the visit from the Long Island suffrage leaders led by Harriet Burton Laidlaw in November 1907 at his home at Sagamore Hill.

But while lukewarm about suffrage, Roosevelt nonetheless revered women. He considered women superior to men, especially in a moral sense; he abhorred men who abused their wives and felt that in marriage "she was as much the head of the house as he; she was as much entitled to education and self-realization as he; the money he earned was as much hers as his; and there was no more reason why she should obey him than he her.[138] He kept married women and mothers on an even higher moral plane than men. But although he believed that women were intrinsically equal to men, he also believed that they needed protection. He was overly protective of his daughters and daughters-in-law, as well as any other women within whom he came in contact. Perhaps he thought politics too tawdry an arena for women.

His public expressions concerning suffrage began to change dramatically in 1912 when he was again nominated to run for president of the United States, this time on the third-party ticket of the Bull Moose Party. When Roosevelt left the White House in 1909 after two terms, he was succeeded by William Howard Taft, also a Republican. At first, Roosevelt had favored Taft, writing him encouraging and flattering letters, offering him what was to Roosevelt judicious advice. Roosevelt tried to mold Taft to his own image, a younger version of himself. He was confident that Taft would continue to espouse and promote many of Roosevelt's Progressive issues, such as his concerns for the environment and the prohibition of child labor.

But Taft had his own ideas of how the presidency should be run, and those often differed from Roosevelt's, much to the former president's dismay. A rift developed between them, and Roosevelt decided to once again run for the presidency on the Republican ticket. (He was entitled to run twice on his own since his first term had resulted from the assassination of President McKinley.) But in June 1912, the National Republican Convention nominated Taft to run for a second term; Roosevelt and his followers stormed out of the convention hall, reconvened at another meeting and founded the Bull Moose Party.[139]

In August 1912, the Progressive Bull Moose Party held its own convention in Chicago. Despite the brief lifespan of the party (barely two months) the

hall was crowded with more than two thousand delegates and alternates, many of them women—female doctors, lawyers, teachers and community activists. Women flocked to the Progressive Bull Moose Party because they were convinced that finally there was a political party that would promote woman suffrage, and indeed, the Bull Moose Party was the first to have a plank recommending woman suffrage in its platform. And as had been expected, the convention nominated Theodore Roosevelt to run for president on the party ticket. In his speech before the August 6 convention, Roosevelt declared, "Working women have the same need to protection that working men have; the ballot is as necessary for one class as to the other; we do not believe that with the two sexes there is identity of function; but we do believe there should be equality of right and therefore we favor woman suffrage."[140]

Not only did the party welcome women, it encouraged them to take an active role and offered them leadership positions. Convention delegate Elinor Carpenter was appointed as a member of the New York State Executive Committee and was charged with the task of organizing a woman's bureau. Women were elected as delegates to the New York State convention, and activist Jane Addams served on the executive committee of the Progressive National Committee. The support of the Bull Moose Party advanced the cause of suffrage, as well as other political rights for women, as no party had done before. Neither Taft nor the Democratic candidate Woodrow Wilson supported suffrage, and it would be years before Wilson finally changed his mind.

In the election that year, the Bull Moose Party was defeated; Taft and Roosevelt split the Republican vote, and Woodrow Wilson was elected. But the tide was finally turning toward granting equal rights to all women, and Theodore Roosevelt was finally taking the lead.

Once converted, he never wavered, and in the years to come, he would speak out strongly in favor of granting women the vote. In November 1915, when the amendment to the New York State Constitution granting women suffrage was proposed, he wrote a letter of strong support, noting that "from time immemorial in monarchies women have been deemed fit to hold the very highest place of governmental power; the position of sovereign…They are entitled to this and they should have it."[141] In September 1917, with the amendment again coming up for a vote, he invited suffrage leaders to visit him and Edith at his home at Sagamore Hill. The *Suffolk County News* was there: "Colonel Roosevelt in his address showed how the war has brought more inevitably than ever before a realization in thinking men and women that universal suffrage is a part of world democracy."[142]

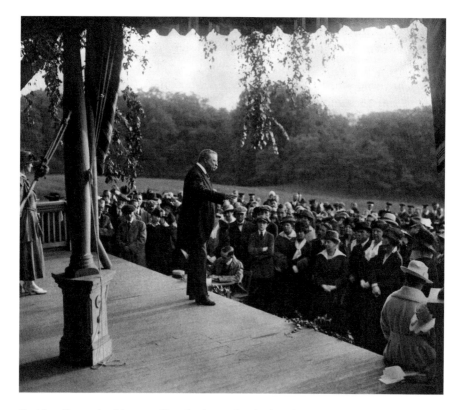

President Roosevelt addresses suffrage leaders and enthusiasts from the porch at Sagamore Hill in Oyster Bay on September 8, 1917, reiterating his support for votes for women. *Courtesy of the U.S. Department of the Interior, National Park Service, Sagamore Hill, National Historic Site.*

On New Year's Day 1919, in one of his last acts before he died, Roosevelt dictated an article to be published in *Metropolitan* magazine, reiterating his strong support for the passage of a constitutional amendment granting equal voting rights to women. Unfortunately, he did not live to see that goal achieved; he died just a few days later on January 6, 1919.

Theodore Roosevelt may have come a bit late to the dance supporting woman suffrage, but once there, he was a stalwart defender whose support never wavered. Always a champion of women in general, he was finally convinced that suffrage was the right of everyone, and without all citizens, both men and women, enjoying that right, the country could not fulfill its claim of promoting democracy and freedom for all. "I was converted from a passive suffragist to an active suffragist, by seeing women who had been doing social reform work,"[143] he once said, and once converted, he proved to be a strong and unwavering ally and a faithful friend.

IDA BUNCE SAMMIS

1868–1943

Je-ru-sa-lem! Women in the Assembly!
—guard at the New York State Assembly

The parlor reserved for members of the New York State Assembly was bustling that cold New Year's Day in 1919; members of both houses of the new legislature were excitedly gathering, preparing to move to the Assembly chamber, where Governor Alfred E. Smith was about to be inaugurated. Members were chatting amiably, discussing the recent signing of the armistice agreement ending World War I and speculating on the fate of future bills and proposals. An armed guard stationed at the entrance to the chamber admitted the members without question but suddenly stopped one with a menacing brace of his rifle across the doorway.

"You'll have to go by another door," he said severely. "Only members of the assembly admitted here."

"But I am a member of the Assembly," the legislator insisted, rooting around in her purse for the proper identification card.

"Nothin' doin', lady." the guard insisted menacingly. "You'll have to go to the other door." It was only when the proper identification was presented and it was proved that, indeed, the lady was a duly elected member of the New York State Assembly that the guard reluctantly granted her admission, murmuring under his breath as she passed, "Je-ru-sa-lem! Women in the Assembly!"

Ida Bunce Sammis later recounted her feelings in the magazine *State Service*: "Women in the Assembly! Dreams come true! The long battle for the

women for political equality seemed won. I was thrilled by the opportunity for service which my new office gave me; yet sobered to by a sense of responsibility as a pioneer in the law-making body of our State."[144]

Along with Mary M. Lilly of the Seventh District in Manhattan, the two were the first women in the history of New York State to be elected to the state legislature. Ida only served one term in the Assembly (in 1919, the term for an Assembly member was for one year), but her accomplishments for that one year were truly remarkable and proved without a doubt that women were perfectly equal with men to the task of governing the state and the nation. Of the fourteen bills she introduced, ten became laws that had a positive impact on what mattered most to her—the education, social welfare and public health concerns of her constituents and their families.

During her tenure, she worked closely with other lawmakers and successfully sponsored legislation improving working conditions for female elevator operators, provided funds for the care and education of disabled children and ensured that the salaries of both men and women in state-run hospitals were equal. She also received accolades for a bill passed into law that extended the season for duck hunting two additional weeks, no small feat as that extension had been unsuccessfully sought by her predecessors for fifteen years!

Ida was born in 1868 to sea captain Eliphalet Bunce and his wife, Margaret Jones Rogers Bunce, in Cold Spring Harbor, New York. Her family was one of the earliest to colonize Long Island, settling in the Huntington area in 1656; her ancestors fought in both the Revolutionary and Civil Wars. Like many women, Ida Bunce Sammis's road to achieving woman suffrage was a long and circuitous one and was built on the experience gained by campaigning for another cause, one that was espoused by her whole family.

Her grandfather had been converted to the temperance movement as a young man, and by the time Ida was born, the entire family was "dry." Ida recalled joining in campaigning against alcohol as soon as she was "big enough to sing temperance songs," and when she was older, she worked in the slums of New York City, trying to convince anyone who would listen that "drunkenness was the greatest evil of the times."[145] It was to this cause that she gave her first passionate devotion; temperance introduced her to both the joys and challenges of working for progressive social issues.

But no progressive movement could ever succeed if its proponents were restricted by silence. For years, attempts by women to secure equal rights were hampered by a strict censure on public speaking. "Respectable" women cleaved solely to hearth and home and never left that arena to speak

in public. Even when called on to defend herself in a court of law, a woman was required to have a man speak for her.

Quaker women were the first to break through this censure; their religion had always believed in the equality of women, and they were allowed to speak freely in the Quaker meetinghouse. Many of the women who had attended the woman's rights convention in Seneca Falls in 1848 were Quakers, including leader Lucretia Mott, and they were able to build on this limited freedom to branch out, speaking in public on other issues that espoused the common good, such as abolition and temperance. These skills of learning to speak in public and developing political alliances would prove useful as they moved from fighting for temperance to fighting for suffrage.

Ida Bunce Sammis's life perfectly illustrated this transition. After being educated in private schools, she married Edgar A. Sammis in 1890; they had one son, and the family lived on East Main Street in the village of Huntington. Edgar, she once told a newspaper reporter, "was in full sympathy with her public activities, which have covered the entire period of my womanhood."[146] But Ida recognized early the danger in trying to align the suffrage and temperance movements. The pursuit of temperance might anger many men whose favor they needed to win the vote, and additionally, many women were themselves not prohibitionists and enjoyed drinking alcohol. And since the liquor industry had consistently worked against the suffrage movement, fearing that women with the vote would vote for prohibition, Ida was wary of angering them further.

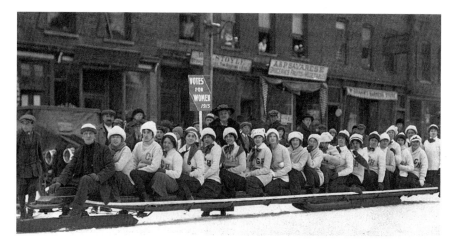

Ida Bunce Sammis (center) sponsoring a bobsled team for suffrage, 1915. Their "Votes for Women" badges were pinned to the backs of their sweaters so that they would be seen as they rode in a twenty-person sled. *Courtesy of Bryn Mawr College Special Collections.*

By 1911, Ida had put temperance work aside and was devoting all her energies to the cause of suffrage. That year, she founded the Huntington Political Equality League, with herself named as president, and Harriett May Mills, president of the New York State Woman Suffrage Association, as honorary president. In November of that year, the league held its first open meeting and agreed not to limit its work to the Huntington area but rather to "extend its influence as rapidly as possible throughout the eastern end of Long Island."[147] It met regularly afterward, usually in Ida's home in Huntington on East Main Street.

The meetings followed a carefully crafted program, beginning with discussion of current events regarding suffrage, and often included a civics lessons or a speech designed to educate the members on suffrage-related issues. Petitions were signed supporting local hygienic methods in the schools, such as drinking fountains for children. All manner of public quality issues were discussed, such as child labor laws and settlement houses that aided immigrants and the poor. For many of the women, it was their first taste of political activity, and the number of members grew.[148]

Ida was soon asked to speak at other local meetings and to hold office in other political organizations. She helped to organize a Woman Suffrage Convention at Patchogue on May 29, 1914, where NAWSA president Carrie Chapman Catt was the main speaker. Her friendship with Catt helped her to emerge as a dominant political force in the suffrage movement not just in Huntington but throughout Long Island as well.

Carrie Chapman Catt was a forceful leader who in 1916 devised what was called the "Winning Plan," which concentrated NAWSA's energies almost solely on the passage of the federal amendment. Her strategy contrasted with that of others, who believed that NAWSA should continue to campaign for suffrage state by state, a method that Catt felt had been ineffectual. She believed that suffrage leaders should concentrate most of their efforts on a more aggressive policy that would enfranchise all women in the United States at once.[149]

During World War I, Catt made it very clear that NAWSA supported President Wilson and the war and encouraged suffragists to show their patriotism by being active in the Red Cross, canteen service and food drives. As much as she personally hated the war, she believed that women would be "rewarded" for their support of the war with the vote.[150] She knew that New York State was a pivotal state in the fight, and like Harriot Stanton Blatch, she believed that if the New York legislature could be convinced to grant women suffrage within the state, it would most likely tip the scales in favor

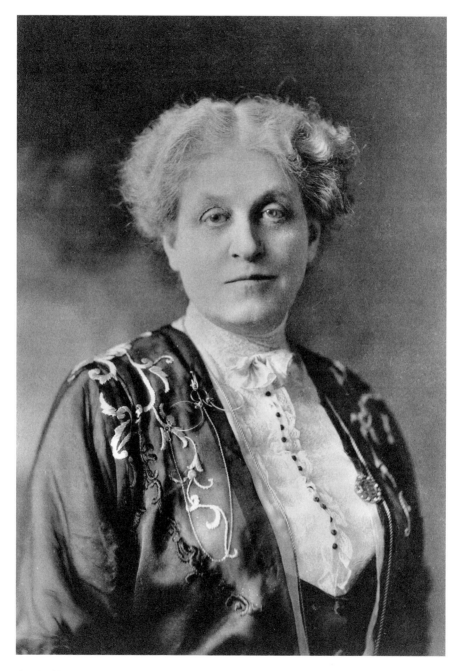

Carrie Chapman Catt, president of NAWSA. *Courtesy of the Library of Congress.*

of a federal amendment. Thus she firmly encouraged locally based activities such as those of Ida's Political Equality League.

Under her Empire State Campaign, twelve campaign districts were established throughout New York State, with a leader for each of the 63 assembly districts and a captain for each of the 2,127 election districts.[151] Ida served as an officer of the Second Assembly District, which by 1915 boasted more than 2,000 members. A chairperson reported each club's activities to the state organization. Ten individual clubs were formed throughout the Long Island area, in Huntington, Amityville, Babylon, Bay Shore, Cold Spring Harbor, Islip, Lindenhurst, Northport, Sayville and Smithtown.[152]

Ida organized rallies and open-air meetings; in an effort to attract men to support the cause, she organized a suffrage baseball team, with pro-suffrage women playing against anti-suffragists. (The suffragists won the first best-of-three series![153]) Suffrage "pilgrimages" wound their way across the island, out over the north and south forks and back through Hempstead, Mineola and Glen Cove. Women made speeches in town squares, distributed literature, collected funds and encouraged all men to vote for the suffrage bill in November. On March 12, 1915, Ida wrote in the *Long Islander*:

> *We are, therefore, confident that, when the amendment to enfranchise women is submitted to the men of this district in November they will prove, by their votes, that they believe that the women of Suffolk County are as worthy of having a voice in the government as are the women of Chicago or San Francisco, and that they believe in woman suffrage because it is right and just, and because no country can be truly a republic that disfranchises half of its citizens.*

Despite these efforts, on November 2, 1915, the referendum in New York State was defeated. In Suffolk County, it lost by 1,670 votes, in Nassau County by 1,450 and in Queens by 11,270 votes.[154] But, as we saw in other chapters, rather than being defeated, suffrage leaders immediately began their campaign to again see the issue on the ballot in 1917. Public opinion began to change, and the tide began to shift in favor of suffrage.

On October 30, 1917, the Long Island suffragists joined with others from all over New York State in a massive march down Fifth Avenue. On November 6, 1917, New York State finally agreed to enfranchise half its population. This time, the numbers showed a startling reversal—the

measure had been passed by 1,994 votes in Nassau, 342 in Suffolk and 6,582 in Queens.[155] Women in New York State were finally given full voice in the governing of their nation.

In 1918, Ida surprised her friends and colleagues by announcing that she was running for political office for a seat in the New York State Assembly, the first woman to ever do so. Her first battle would be in the Republican Primary, where she faced challenger Henry A. Murphy. She returned to her temperance roots by portraying Murphy as an advocate of "demon rum." "Men like Murphy," she said, "are a liability and a hindrance to their party in times of peace—in this time of war there is no place for them in the party of Abraham Lincoln."[156] She proved to be a formidable opponent and easily won the nomination. As Assemblyman John J. Flanagan wrote in his essay "First Woman of the House":

On November 2, 1915, New York suffragists hoped the vote on an amendment to the New York State Constitution would pass, finally granting women in New York the right to vote. Buttons and other publicity items were issued to help spread the message. Unfortunately, the measure was defeated in 1915 but passed in 1917. *Courtesy of the Suffrage First Media Project, author's collection.*

Thousands of new women voters completely remolded the electorate as no other time before. Women registered and they came to play…It was their first vote and they weren't about to waste it. Ida Sammis and the ladies of Huntington took Henry Murphy to the cleaners. Town politics would never be the same. The "Men Only" sign had been removed from the door.

Despite her somewhat adversarial campaign statements, Ida ran on a platform promising a "good, clean, honest administration." Her temperance background stood her in good stead, and many backed her because of her support for prohibition. On November 18, 1918, she defeated both Democratic candidate Walter L. Stillwell and Socialist candidate Eugene Wood, carrying every town in her district.[157]

Ida Bunce Sammis's tenure in the New York State Assembly was short. The following year, she was defeated in her bid for reelection. But the work she accomplished, both for suffrage and as assemblywoman, was prodigious; she fought for equality and improved social conditions not just for her gender but for all her constituents. And she rejoiced with the women throughout the nation when they finally achieved universal suffrage in 1920. She continued to work for social issues until her death in 1943.

Ida's first husband had died in 1917. She married Alden J. Woodruff, a retired doctor, in 1923, and after his death, she married for the third time to George E. Satchwell. Despite her work for suffrage, it is her election to the Assembly that forged Ida's place in history and profoundly affected her entire life. Ida was happy to have served in 1919 because it was the year in which both the woman suffrage and the prohibition amendments to the constitution were ratified—both issues she had spent her adult life fighting for. In an interview with *State Service* magazine, she spoke of the privilege she had been given to introduce the prohibition amendment in the Assembly:

Never, until I die, shall I forget that scene—that historic chamber, the grouping of the opposition, the solid Republican front, and out-numbering all the other groups, the hundreds and hundreds of cheering women whose day had come! The day in which they are to share with men, not only the responsibility for forming public opinion but the responsibility for making the laws—the new day![158]

Ida Bunce Sammis could take real satisfaction in her role in creating that new day.

Chapter 12

ELIZABETH OAKES SMITH

1806–1893

Do we understand that we aim at nothing less than an entire subversion of the present order of society, a dissolution of the whole existing social compact?
—Elizabeth Oakes Smith

The casket lay cold and abandoned on the station platform, its polished wood surface buffeted by the wintry wind. Throughout the bleak and frigid day, no one stepped up to claim it; its occupant lay alone. Finally, as day darkened into night, the local undertaker arrived to bear it to its final resting place, with no one to say a prayer, no one to pay tribute to the life its tenant had lived.

Elizabeth Oakes Smith was buried that day at the Patchogue cemetery. But the cold winter's day and the lonely burial were in sharp contrast to the life she had led, a life effused with the warmth of love and achievement. As in all lives, there had been sorrow as well as immense success, and the writings and speeches that framed her legacy were graced by an enduring truth that no winter's cold wind could diminish.

Elizabeth Oakes Smith was born in Yarmouth, Maine, second daughter of Sophia Blanchard and David Cushing Prince, who was part owner of a trading ship. As a child, she was exposed to both the liberal French Huguenot beliefs of her maternal grandfather and the staunch Puritanical beliefs of her paternal grandfather, a combination that resulted in her frequently questioning rules and status quo. The dichotomy of these two very different ways of approaching the world would always present her with difficulty, but

it would also help her to forge an identity as a freethinker at an early age, "early questioning what she could not accept or understand in her life."[159]

Her father died when she was two years old; her mother soon remarried, and in 1814, the family moved to Portland, Maine. Elizabeth learned to read at an early age, and as she grew older, she began to hunger for more education, begging her mother to allow her to study "all the lessons the young men learn" and eventually open a school for girls. But Sophia followed David Cushing's Puritan faith that believed that the best and only path for girls was an early marriage. To please her parents, Elizabeth gave up her dreams of an education, "folded her wings" and reluctantly bowed to convention. She was married in March 1823 at the age of sixteen to Seba Smith, a writer almost twice her age. In her autobiography, she noted that she was "a mere baby, no more fit to be a wife than a child of ten years."[160]

Not surprisingly, marriage was difficult for Elizabeth. At the age of sixteen, she suddenly found herself in charge of one servant and six apprentices in her husband's printing business. "I had lost my girlhood and found nothing to take its place," she recalled later, and the hunger for education still burned. She could not understand why men were free to pursue their goals and dreams, while marriage for women was "annihilation." Still, she applied herself to marriage and gave birth to five sons. She did not regret having only sons but was secretly glad "not to add to the number of human beings who must be from necessity curtailed of so much that was desirable in life; who must be arrested, abridged, engulfed in the tasteless actual."[161]

As a married woman, Elizabeth found Portland to be an exciting and stimulating city, churning with literary and political activity, a city "alert for the best ideas and appreciative of the best men and women." Discussions of abolition and temperance and all manner of political and social change swirled around her. Her marriage to Seba seemed to be a happy one; the couple read Shakespeare and other classics together. Elizabeth joined the Unitarian Church and began writing poems and children's stories for local literary periodicals. Seba's career was blossoming, and he garnered publicity and fame for his humorous political commentary, "The Jack Downing Letters."

But in 1839, the family's fortunes took a downturn. Seba had invested in land speculation and had lost heavily. After a brief stay in Charleston, South Carolina, they moved to New York in an attempt to capitalize on that city's literary opportunities.[162] Throughout this difficult time, Elizabeth supported her husband, but she felt frustrated and helpless as a married woman with no legal rights. "Internally I vented my spleen upon the false position held by women, who seemingly could do nothing better than suppress all screaming

and go down with the wreck,"[163] she wrote in her autobiography. But Seba's financial misfortune actually worked to Elizabeth's advantage. Once in New York, she began her writing career in earnest, and the Smiths began to be known as a "literary couple," attending salons and gatherings with such literary luminaries as Edgar Allan Poe; Horace Greeley, editor of the *New York Tribune*; William Cullen Bryant; and Sara Josepha Hale, publisher of *Godey's Lady's Book*.

The encouragement and support of these friends led her to write one of her first major works, "The Sinless Child," which was published in the *Southern Literary Messenger* in 1843. Elizabeth was paid fifty dollars for this tale of a young girl and her widowed mother; many thought it was the story of Elizabeth herself:

> *She felt the freedom and the light*
> *The pure in heart may know*
> *Whose blessed privilege it is*
> *To walk with God below;*
> *To understand the hidden things*
> *That others may not see,*
> *To feel a life within the heart,*
> *And love and mystery.*[164]

But while the sinless child kept herself apart from life, Elizabeth did just the opposite—writing and publishing more stories and poems and becoming even more famous and successful than her husband. Her dreams of having her own talents recognized were finally beginning to be realized.

With this newfound success came the confidence to finally write about what concerned her the most: the full acceptance of women as equal partners in marriage and in the citizenry, with the right to vote, hold property and receive equal pay for equal work. In 1851, Horace Greeley's *New York Tribune* published her next major work, "Woman and Her Needs," a series of articles in which she finally gave voice to the frustrations she had faced as a young wife, describing the sad fate of "girl wives hardly escaped from pantalets." The truths of those articles resonate to this day:

> *Every true woman should assert her right to pecuniary independence—to*
> *a position secured independent of the affections;…Allow women the rights*
> *of property, open to her the avenues to wealth, permit her not only to hold*
> *property, but to enter into commerce, or into professions if she is fit for*

them…Hereafter, in the progress of events I see no reason why the influence of women should not be acknowledged at the ballot box: indeed when we consider the disorder and venality prevailing there, it would seem that her voice may be the great element needful to reform.[165]

In 1851, these ideas were unheard of, yet her voice was welcomed, and she became one of the first women to travel and speak on the Lyceum circuit, a popular circuit of writers, speakers and entertainers. But her presence on the circuit was not well received by some of her friends, including Catherine Beecher, sister of Harriet Beecher Stowe. "For a woman to mount the rostrum and give utterance to her own views or opinions was presumptuous, not to say indecent," Elizabeth admitted in her autobiography. But Elizabeth continued to do just that, lecturing to women that the rights of citizenship, including the right to vote, would help to cure the ills of many, especially women who had to work for a living. In 1851, she shared these ideas at the Second National Woman's Rights Convention in Worcester, Massachusetts, where she joined Susan B. Anthony and Lucretia Mott on the platform. The following year, she delivered a speech at the convention in Syracuse:

I trust this will not be a mere talking Convention. We have talked long enough. For years brave women have talked and have appealed to us who are younger in the work and have encountered nothing but contempt and odium. Let us have done with so much talk and let us act. Let us take our right.[166]

Elizabeth's career on the Lyceum circuit continued through 1857. Response to her speeches was mixed. Henry Clay called her "irresistibly fascinating," while some walked out of her lectures, angered when they heard her lecture on the unpopular belief that woman should not be forced to marry but instead should have professions and avenues of support open to her to enable her to support herself.

In 1859, the Smiths bought a large house in on West Main Street in Patchogue, Long Island, that had been owned by Revolutionary War hero Nathaniel Woodhull. They called the house the Willows and spent several happy years there. The house was a comfortable refuge for them and held many books and mementos of their literary lives and friendships with Ralph Waldo Emerson and Henry David Thoreau. Elizabeth took an active interest in the politics of her new hometown and helped collect supplies for young men from the area who had enlisted in the Union army.

But the years following the Civil War were not easy for the Smiths. One son died of yellow fever in 1865, Elizabeth's husband Seba died in 1868 and another son drowned in 1869. She moved to a smaller house in nearby Blue Point, Long Island, and began to embrace spirituality and religion to help assuage her grief. Throughout these dark years, she continued to write and speak on women's need for autonomy and independence. In November 1868, she lectured at nearby Port Jefferson. She also continued to attend the National Woman's Rights Conventions and served as a charter member of New York's first woman's club, Sorosis.

In later years, she moved to North Carolina to live with

Grave of Elizabeth Oakes Smith, Lakeview Cemetery in Patchogue. The stone was knocked over and cracked in half, but it was repaired. Seba's grave is next to Elizabeth's. *Courtesy of the Suffrage First Media Project, author's collection.*

one of her sons, still remaining active in temperance and suffrage societies. She died in 1893 and is buried in Patchogue, next to her husband and near where their beloved house the Willows once stood.

Elizabeth Oakes Smith was one of the first to actively speak out about the need of women to listen to their own hearts, follow the spirit and talents within and not accept someone else's plan for their life. She dared to insist that women were "capable of thinking, and may be far more capable of it than those of their own household who help to sway the destinies of the country through the ballot box." While not an enemy of men, she deplored their attempts at control. "Men have written for us, thought for us, legislated for us and they have constructed from their own consciousness an effigy of a woman to which we are expected to conform."[167] Although there was no formal suffrage group in Patchogue when she lived there, she helped to raise the awareness of the need for such a movement through her writings and

speeches, and in doing so she paved the way for suffragists who would follow. Her voice resonates to this day with a wisdom that both men and women can understand:

> *Let woman learn to take a woman's view of things. Let her feel the need of a woman's thought. Let her search into her own needs—say, not what has the world hitherto thought in regard to this or that, but what is the true view of it from the nature of things. Let her not say, what does my husband, my brother, my father think, wise and good and trustworthy though they be—but let her evolve her own thought, recognize her own needs, and judge of her own acts by the best lights of her own mind.*[168]

Chapter 13

OTHERS WHO DARED

While many women on Long Island made winning the vote their life's work, there were scores of others whose family and professional duties precluded full-time dedication but whose work was still valued. Many led lives that attracted little attention, so little is recorded about them. Some were of modest means, while many were wealthy beyond imagining. Suffrage leaders knew that they had to enlist women from all social and financial strata and convince them that suffrage would benefit their lives, no matter their income or social standing. While it is impossible to name all the women involved in the suffrage movement on Long Island, the ones named here are some of the most well known.

MARY LOUISE BOOTH was born in Millville (later known as Yaphank) on April 19, 1931. Her father, William Booth, was the local miller and schoolteacher who believed strongly in the value of education for girls. Through diligent study, she became fluent in seven foreign languages, and later, when her father became principle of a school in Williamsburg (later known as Brooklyn), she joined him there as a teacher. She began a literary career as a translator during the Civil War, translating works by French writers who were supporters of the Union cause, and continued this profession for the rest of her life. In 1867, she became the editor of the fledgling publication *Harper's Bazaar*, a position she also held until her death.[169]

Her work for suffrage began after a chance meeting with Susan B. Anthony. She served as first secretary to the woman's rights convention in

1855 in Seneca Falls, New York. While not one of the most active suffragists, she served as an example that women could hold a difficult and arduous position in a profession that had been previously dominated by men. She died in 1889.

GERTRUDE FOSTER BROWN, from Bellport, was a concert pianist who served as chairman for the Empire State campaign in 1915 and was a vice-president of NAWSA.[170]

IRENE CORWIN DAVISON was born in East Rockaway in 1872, attended the Packer Collegiate Institute in Brooklyn and later graduated from Pratt Institute. She taught art in the Jericho schools and became the first woman to open her own insurance agency. When her father died, she took over his farm, creating one of the first housing developments on Long Island.

Irene never married and devoted her personal and financial freedom to suffrage. She was a good friend of Rosalie Gardiner Jones and joined her famous marches to Albany and Washington, D.C. In 1915, Irene worked with Edna Kearns as a poll watcher. The two canvassed voters at polls in Sayville, asking them to sign a slip of paper stating, "I believe that the vote should be granted to the women of New York in 1915."[171] Irene's sisters, Amelia and Susan, were active suffragists as well.

In September 1913, always seeking unique and innovative activities to garner publicity, Irene and her friends staged an all-night "Aerial Party" on the Hempstead Plains aviation field (which later became Roosevelt Field). The *New York Times* reported, "About 200 women and eight men were marshaled for the parade down Hanger Row." Present were other well-known suffragists Harriet Burton Laidlaw and Mrs. Rhoda Glover, said to be the oldest suffragists in Nassau County.[172]

MINSARAH (SARAH) J. SMITH GARNET was born on Long Island on July 31, 1831, on the Shinnecock Indian reservation in Southampton, Long Island.[173] Her family would eventually move to Queens County (later known as Brooklyn) and would welcome nine more children. Her father was a prosperous pork merchant in Weeksville, the oldest African American community in Brooklyn.

In 1845, at the age of fourteen, Sarah began working as a teacher's assistant in the African Free School in Williamsburg, founded in 1787 by the antislavery New York Manumission Society. In 1863, she was appointed principal of Grammar School No. 4, the first African American woman

to hold such a position in the New York City school system, a post she would hold for thirty-seven years.

In the late 1880s, she organized the Equal Suffrage League, the first organized in Brooklyn by an African American woman. After her retirement, she traveled to England to learn about the suffrage movement's activities there. She worked on the national scene as well as the local, becoming superintendent of the suffrage department of the National Association of Colored Women, and also worked on the Niagara movement, which was a forerunner of the NAACP.[174]

Sarah Garnet entered the field of education in 1845 at a time when slavery was still a reality and when there were virtually no opportunities for young African American women. She fought her entire life to secure educational opportunities

Portrait of Sarah (Minisarah) Garnet, first African American woman to found a suffrage organization, the Equal Suffrage League in Brooklyn, in the late 1880s. *Courtesy of Documenting the American South, the University of North Carolina at Chapel Hill Libraries.*

for her race and later political equality for her sex, acting as a powerful role model for her students and her family, including her sister, Susan McKinney Stewart, who became the first African American female physician.

CLARE BOOTHE LUCE worked as an assistant to Alva Vanderbilt Belmont, traveling with her to the seventy-fifth anniversary of the women's rights convention in Seneca Falls. She lived for a time in Sands Point.[175]

MRS. THOMAS L. MANSON was one of the most active leaders on the East End. Born Mary (or May) Groot on June 23, 1859, she married Thomas L. Manson, who owned the Thomas L. Manson Stock exchange firm in Manhattan. The couple had three children and divided their time between homes in New York City and East Hampton, where they lived on Main Street.

Before she began her suffrage work, Mrs. Manson was an active philanthropist in the East Hampton community, raising funds to benefit the

The suffrage tent at the Suffolk County Fair in Riverhead, 1914. Perhaps to dispel the perception of suffragists as "marriage-hating spinsters," the WPU hung a sign: "WPU Suffrage Tent. Children cared for here no charge." More than one hundred women took advantage of the offer, including one mother who, accidentally, did not return until the next day. *Courtesy of the Library of Congress.*

Jewell Nursery that cared for poor children and working to help the soldiers at Camp Wikoff at Montauk Point, where a military unit of veterans of the Spanish-American War was billeted. Conditions were poor at the camp, and Mrs. Manson and the East Hampton Relief Corps provided blankets, warm clothing, medical supplies and food to the soldiers as they awaited release to return home.[176]

When Mrs. Manson turned to suffrage work, she served as head of the WPU in East Hampton, arranging rallies and dances and sponsoring speakers. A highlight of the 1913 social and suffrage season was the Open Air Suffrage Meeting, held on August 23 at Mrs. Manson's home on Main Street in East Hampton:

> *A cordial invitation is extended to all Suffragists and also to all who are merely interested in the cause, to come to the house of the chairman of the Executive Committee of the Woman Suffrage League of East Hampton, Mrs. Thos. L. Manson to meet Mrs. Harriot Stanton Blatch, President of*

the Woman's Political Union…Women are requested to wear a white waist and skirt or a simple white dress.[177]

The next month, Mrs. Manson and Harriot Stanton Blatch spoke to large crowds at the Riverhead Fair, where the WPU pitched a "suffrage tent" to catch the interest of women who attended the fair. Women could leave their children at the suffrage tent while they enjoyed the fair, and more than one hundred women availed themselves of the service.[178] In 1915, Mrs. Manson also played a major role in transporting the Suffrage Torch from Montauk Point across Long Island, eventually passing the Torch over to Louisine Havemeyer. Unfortunately, she died before full suffrage was achieved.

CORNELIA BRYCE PINCHOT grew up in Roslyn Harbor and worked from an early age to promote equal rights for women. She campaigned for Theodore Roosevelt during his campaign as a candidate of the Bull Moose Party in 1912, during which she met her future husband, Gifford Pinchot, whom she married in 1914. She moved with him to Pennsylvania, where she continued her work for both woman suffrage and to better the lives of women and children everywhere.[179]

FLORENCE GIBB PRATT was married to Herbert Lee Pratt, fourth in line of the Pratt brothers. She was born in Brooklyn on November 3, 1872, into a family of eleven children. Her father, John Gibb, had emigrated from Scotland and was a wealthy merchant who imported lace and upholstery. Her mother, Harriet Balsdon, was born in England and died when Florence was six years old.

Florence graduated from the Packer Collegiate Institute in Brooklyn in 1894 and married Herbert Lee Pratt a few years later in 1987. She and her husband lived in Manhattan and built their summer home near the other Pratt siblings in Glen Cove in 1902. Herbert Lee built his mansion on the shore of Long Island Sound and named it the Braes (now the home of Webb Institute of Naval Architecture). The Pratts were strongly involved in philanthropic causes throughout the island. Florence Gibb Pratt contributed to the founding of Nassau Hospital in Mineola (now Winthrop Hospital), later serving on its board of trustees. She also served on the local school board and was the first woman to be elected to the New York State Board of Regents.[180]

In December 1917, Florence held the post of treasurer of the Woman Suffrage Party of New York City, as well as third vice-chairman of the Manhattan

Borough. That same month, she joined a group of delegates from New York State and traveled to Washington, D.C., for the NAWSA convention.[181]

HELEN DEMING SHERMAN PRATT was also born in Brooklyn, on October 21, 1869, to John Taylor Sherman and Julia Champion Deming, the fifth of eight children and the fourth daughter. John Sherman was a descendant

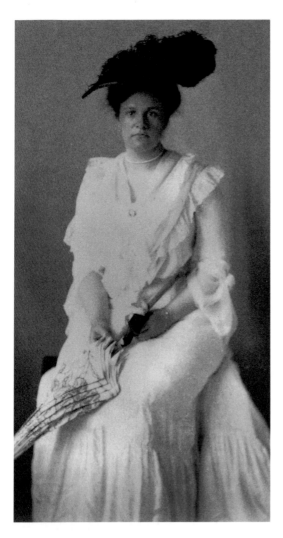

of Roger Sherman, crafter and signer of the U.S. Constitution. Helen attended the Packer Collegiate Institute around the same time as Florence Gibb. She married George DuPont Pratt in 1897, and the couple built their house, Killenworth, on Dosoris Lane in Glen Cove that same year.[182]

All the Pratt siblings lived literally around the corner from one another in Glen Cove. The sisters-in-law must have seen each other frequently, and both were active in various philanthropic causes. Helen Deming Sherman Pratt was one of the founders of the Lincoln Settlement House in Glen Cove, which catered to the needs of the African American community in Glen Cove.[183] She was a member of the Woman's Trade Union League and later of the League of Women Voters. Both families donated their

Helen Deming Sherman Pratt. *Courtesy of the Robert R. Coles Long Island History Collection, Glen Cove Public Library.*

own money to the cause but also helped raise funds through theatrical performances, rallies and meetings.

Helen and George Pratt often opened their house to suffrage meetings and fundraisers. In 1918, both Pratt families were listed as being generous contributors to the annual campaign. Later, after suffrage was won, Helen hosted the first Convention of the League of Women Voters at Killenworth.

KATRINA ELY TIFFANY made her home a bit farther east of Glen Cove in the village of Oyster Bay Cove, daughter-in-law of the famous artist Louis Comfort Tiffany and wife of Louis's son, Charles. She was born on March 25, 1875, in Altoona, Pennsylvania. Her father was an engineer who worked on the Pennsylvania Railroad. Her mother, Henrietta Brandes, was the daughter of a well-known physician and surgeon Dr. Charles Von S. Brandes. Dr. Brandes was known for his liberal ideals and his devotion to unpopular causes, and it is believed that Katrina derived much of her later devotion to struggling causes from him.

After her mother died when she was five years old, much of her childhood was spent in private schools or with tutors until she entered Bryn Mawr College in 1893. A lighthearted, adventurous young woman, she devoted herself to causes that she believed would better society. She graduated from Bryn Mawr in 1897 with a degree in chemistry and biology and married Charles L. Tiffany in 1901. The couple divided their time between their apartment in Manhattan and their home in Oyster Bay Cove, and like her contemporaries, Katrina almost immediately became involved in social issues near both homes, including suffrage.[184]

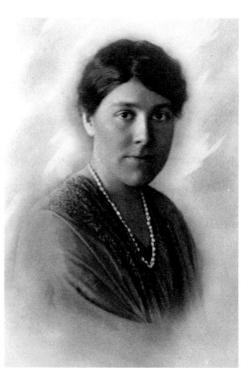

Katrina served as the president of CESL and the

Katrina Ely Tiffany. *Courtesy of the Sophia Smith Collection, Smith College.*

recording secretary of NYWSA. Despite her husband's disapproval of the woman suffrage movement, the Tiffany home was a frequent meeting place for like-minded women. Katrina frequently spoke at the Glen Cove Equal Suffrage Club, which met at 10:00 a.m. on the first Thursday of each month in the Tiny Tea Room, situated in the heart of the village of Glen Cove. The club provided a convenient place for women from the area to meet and plan fundraisers, dances and speeches. Local newspaper accounts reported on visits from other suffrage leaders such as Harriet Burton Laidlaw and Ida Bunce Sammis. Katrina undoubtedly met the Pratt sisters-in-law there; in 1917, she and Florence Pratt traveled to Washington to meet with President Wilson.[185]

Earlier that year, she spoke to the Nassau County Board of Supervisors in favor of suffrage and, along with GRACE CLAPP GREENE, chairman of the Nassau County Woman Suffrage Association, presented them with a petition containing 13,635 signatures supporting woman suffrage, which resulted in the board's endorsement of the movement.[186]

LISBETH HALSEY WHITE lived in Southampton and served as the first secretary of the Southampton branch of the WPU. The WPU held meetings and circulated petitions in favor of amendments to both the New York State Constitution and the U.S. Constitution. Lisabeth hosted meetings at her home, Post House on Main Street of Southampton, and even had cordial dealings with the active anti-suffragist movement led by Mrs. William Donnelly. Later, the WPU was reorganized as the CU, led by Alice Paul and Lucy Burns.[187]

As part of the suffrage picture on Long Island, the anti-suffrage movement was unfortunately alive and well. Anti-suffrage sentiments were not new—the New York State Association Opposed to Woman Suffrage was founded in 1895 by women who had worked to thwart suffragists' attempts to have the word "male" struck from the New York State Constitution in 1894 (see the second chapter). Antis were invited to speak at many of the same organizations as suffragists—labor and Masonic organizations, as well as women's cultural and political clubs. They moved within the same social circles as the suffragists, and some were even in the same family, such as Rosalie Gardiner Jones's mother, Mary Elizabeth Jones.

Those opposed to woman suffrage invoked the old arguments that "women were too dignified and too gentle to vote" and that the vote would sully them and cast them into the unsavory world of politics. Women would leave their homes and children neglected when they went out to vote. Besides, their

husbands, sons and brothers represented their interests, so there is no need for them to have any political concerns. When World War I began, the anti-suffragists heaped public scorn on the suffragists, accusing them of being unpatriotic by continuing to lobby for suffrage.

Much of the anti-suffrage movement was fostered by the distilling and brewing industry, which feared that the vote for women would result in prohibition of the sale and use of alcohol. Ironically, the Eighteenth Amendment to the Constitution was passed in 1918, two years before most American women could vote. After New York women won the vote in 1917, the anti-suffrage movement faded.

The active Long Island woman suffrage leaders knew one another well and took advantage of rallies and conventions to meet, share meals, discuss tactics and plans and cement friendships that were so important to the success of the movement. The City of Long Beach hosted two such conventions, one in April 1916 and the second in April 1917. The *Hempstead Daily Sentinel* announced, "Prominent Workers from All Over the Country Will Speak—Many Local People Will Attend." The conventions gave Long Island women a chance to hear speeches by more prominent leaders; speakers included Harriet Burton Laidlaw, Anna Howard Shaw and Carrie Chapman Catt from NAWSA. By attending these conventions, these prominent leaders were also able to express their thanks to the Long Island suffragists and impress on them the importance of their work.

And work they did. Across the island, in small towns and villages and in larger towns and cities, the men and women wrote letters; published articles; canvassed voters; organized; petitioned; and spoke in the out-of-doors and from the back of automobiles, trucks and wagons. Certainly it could not have been won without the help of men, for they held the reins of power. As we have seen, there were many men on Long Island who worked as equal partners to secure equality for both sexes—James Lees Laidlaw, Hal Fullerton and later President Theodore Roosevelt just to name a few. While their work might not be as well documented, it is valued nonetheless.

Although it is impossible to note every name of everyone who contributed, it is a clear certainty that without the efforts of these lesser-known men and women, the campaign for woman suffrage could never have been won. Here are just a few who might warrant further study:

- Gertrude Foster Brown, Bellport, president of NYSWSA
- Edith Cooper Bryce, Roslyn Harbor (mother of Cornelia Bryce Pinchot)
- Mrs. Sue J. Davison, East Rockaway

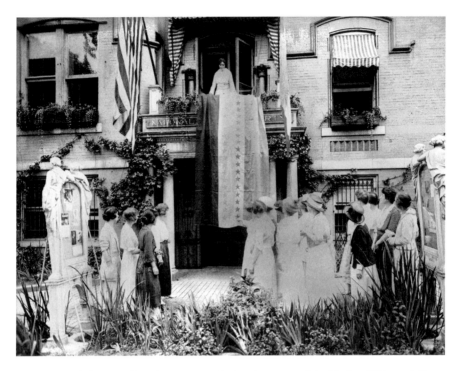

Alice Paul unfurls the suffrage banner over the headquarters of the National Woman's Party on August 26, 1920, just after Tennessee ratified the Nineteenth Amendment, while other suffragists look on. *Courtesy of the Library of Congress.*

- Lillian DeVere, Lake Ronkonkoma
- Mae Duffield, Lake Ronkonkoma
- Edith La Bau Tiffany Dyer, Southampton
- Mrs. Christine Frederick, Greenlawn
- Edith Loring Fullerton and Hal Fullerton, Medford
- Mrs. Rhoda Glover, Baldwin
- Ruth Carpenter Litt, Patchogue
- Mrs. Ward Melville (Jenny), Brooklyn
- Margaret Slocum Sage, Sag Harbor
- Mrs. Gilbert Scudder, Sea Cliff
- Mary and George Stackpole, Riverhead
- Mrs. Susan H. Volmer, Huntington
- Mrs. J.K. Wellman, Rockville Centre

EPILOGUE

On August 26, 1920, Secretary of State Bainbridge Colby certified the Nineteenth Amendment as part of the United States' Constitution:

Section 1: The right of citizens of the United States to vote shall not be denied or abridged by the United States or by any State on account of sex.

Section 2: Congress shall have power to enforce this article by appropriate legislation.

Victory at last.

Casting her first vote. *Courtesy of the Suffrage First Media Project, author's collection.*

Appendix
ABBREVIATIONS

ANB—*American National Biography*
AWSA—American Woman Suffrage Association
CU—Congressional Union
DAB—*Dictionary of American Biography*
EFS—Equal Franchise Society
NAW—*Notable American Women*
NAWSA—National American Woman Suffrage Association
NBAW—*Notable Black American Women*
NCHSJ—*Nassau County Historical Society Journal*
NWSA—National Woman Suffrage Association
NYSWSA—New York State Woman Suffrage Association
PEA—Political Equality Association
PNW—Profiles of Negro Womanhood
SPLIA—Society for the Preservation of Long Island Antiquities
WPU—Women's Political Union
WSPU—Women's Social and Political Union

NOTES

INTRODUCTION

1. Gurko, *Ladies of Seneca Falls*, 2.
2. Ibid., 3.
3. For more information on Seneca Falls (now in the National Park Service), on the text of the *Declaration of Sentiments* and on the signers, go to www.nps.gov/wori/historyculture/seneca-falls-in-1848.htm.
4. This includes what are now the boroughs of Brooklyn and Queens.
5. Horton, "America's First Woman Patentee."
6. DeRiggie, "Wright Sisters," 21.
7. Burke and Meyer, "Spies of the Revolution," 9.
8. The four basic parties at the time were the Democratic, Republican, Socialist and Progressive (Bull Moose) Parties.
9. Cash, "Gender and Raced Consciousness," 134.
10. LaGumina, *From Steerage to Suburb*, 116.
11. See the Hofstra University website.
12. See the Harriet Quimby website.

CHAPTER 1

13. *New York Times*, "Newport Divides on the Suffrage Gathering," August 25, 2009.

14. There is some dispute over exactly when and where the luncheon took place. See the Woman Suffrage Memorabilia website.
15. Alva Vanderbilt Belmont, *NAW*, 1:126.
16. Stuart, *Consuela and Alva Vanderbilt*, 52.
17. Alva Vanderbilt Belmont, *NAW*, 1:127.
18. Stuart, *Consuela and Alva Vanderbilt*, 115.
19. See the Belcourt Castle website.
20. Stasz, *Vanderbilt Women*, 216.
21. Lunardini, *From Equal Suffrage to Equal Rights*, 111.
22. For a more complete account of the White House picketing, see the chapter on Lucy Burns.
23. *Congressional Record*, 56. Some states would take many more years to ratify the amendment, one of the last being Alabama, which did not ratify until 1953.
24. See the Sewall-Belmont House website.
25. Ibid.

CHAPTER 2

26. Blatch and Lutz, *Challenging Years*, 63.
27. Harriot Stanton Blatch, *NAW*, 1:172.
28. DuBois, *Harriot Stanton Blatch*, 8.
29. Blatch and Lutz, *Challenging Years*, 5.
30. Dubois, *Harriot Stanton Blatch*, 36.
31. The British used the term "suffragette," while Americans preferred "suffragist."
32. Blatch and Lutz, *Challenging Years*, 92–93.
33. Ibid.
34. Dubois, *Harriot Stanton Blatch*, 119.
35. *Port Jefferson Echo*, "William Blatch Shocked to Death," August 15, 1915.
36. Fowler, "Carrie Chapman Catt, Strategist," 306.
37. Cooney, *Winning the Vote*, 265. The eleven states that had given women full suffrage by 1915 were Arizona, California, Colorado, Idaho, Kansas, Montana, Nevada, Oregon, Utah, Washington and Wyoming. Others gave partial suffrage.
38. For a more complete account of the White House picketing, see the chapter on Lucy Burns.
39. Blatch and Lutz, *Challenging Years*, 276.

Chapter 3

40. Irwin, *Story of Alice Paul*. Most of the details of the girls' first meeting can be found on page 9.
41. Paul, "Conversations with Alice Paul," 51.
42. Irwin, *Story of Alice Paul*, 11.
43. Bland, "Never Quite as Committed as We'd Like," 7.
44. Lucy Burns, *NAW*, Modern Period, 124.
45. Irwin, *Story of Alice Paul*, 13.
46. *New York Evening Journal*, March 8, 1913, 1.
47. Cooney, *Winning the Vote*, 197.
48. Stevens, *Jailed for Freedom*, 35.
49. A wonderful collection of these cards can be found at the Sewall-Belmont House in Washington, D.C., and on the site's website, www.sewallbelmont.org.
50. Stevens, *Jailed for Freedom*, 19.
51. The most complete account of the campaign to picket the White House and the subsequent abuse of the picketers can be found in Doris Stevens's book, *Jailed for Freedom*, which lists the names of suffragists who were imprisoned, the scripts of the banners and plenty of other information. Many of the original banners are on display at the Sewall-Belmont House in Washington, D.C.
52. Not to be outdone, the House of Representatives would pass it again by an even bigger majority in May of 1919, 304 votes to 90.
53. *Congressional Record*, 56.
54. This award is given every year by the current Brooklyn Borough president. See www.brooklyn-usa.org.

Chapter 4

55. *New York Times*, "Women in Battle," January 7, 1911.
56. *New York Times*, "Suffrage Cheers for Mrs. Pankhurst," October 21, 1909.
57. Her father was a barrister, but no mention of him is found in her records. According to relatives, she had no contact with him.
58. See the St. Johnland Nursing Center website.
59. See the Salvation Army website.
60. Freeman, "Why I Am a Militant Suffragette."

61. Ibid.

62. Ibid.

63. See the Interactive Scrapbook of Elisabeth Freeman website.

64. Freeman, "Why I Am a Militant Suffragette."

65. Harriet Burton Laidlaw, letter written on October 9, 1911. See the Interactive Scrapbook of Elisabeth Freeman.

66. Dublin and Johnston, "How Did Elisabeth Freeman's Publicity Skills."

67. See the Interactive Scrapbook of Elisabeth Freeman website.

68. *New York Evening Journal*, "Girl Quits Luxury to Tramp for Suffrage," June 10, 1912.

69. See the chapter on Rosalie Gardiner Jones.

70. See the Interactive Scrapbook of Elisabeth Freeman website.

71. Dublin and Johnston, "How Did Elisabeth Freeman's Publicity Skills."

72. *Detroit Journal*, "British Suffragist Here in War on Lynching Due to Burning of Boy at Waco," July 21, 1916.

CHAPTER 5

73. Havemeyer, "Suffrage Torch," 534.

74. Louisine Havemeyer, *NAW*, 2:156.

75. See the Mary Cassatt website.

76. Louisine Havemeyer, *NAW*, 2:156.

77. Havemeyer and Stein, *Sixteen to Sixty*, 268.

78. Ibid., 279.

79. Havemeyer, "Suffrage Torch," 529.

80. Ibid., 531.

81. Havemeyer, "Suffrage Torch," 535.

82. Ibid., 536.

83. Havemeyer, "Prison Special," 663.

84. Ibid., 663.

85. Ibid. The complete story of her account is told in "Prison Special."

CHAPTER 6

86. *New York Times*, "Suffragists Finish March to Albany," December 29, 2012.

87. *New York Times*, "Gardiner's Island Will Be Auctioned" March 12, 1937.

88. Spinzia, "Women of Long Island: Mary Elizabeth Jones, Rosalie Gardiner Jones," 3.
89. DeWan, "Long Island Our Past," A42.
90. *Long Islander*, "Miss Jones Don't Like Ohio," October 4, 1912.
91. See the fourth chapter for more details on the Ohio trip with Elisabeth Freeman.
92. Jones, *Tearing Down Walls*, 13.
93. *New York Times*, "Merry Xmas from Marchers," December 24, 1912.
94. *New York Times*, "Suffragists Finish March to Albany," December 29, 2012.
95. *New York Times*, "Suffrage Hikers Undaunted by Cold," February 13, 2013.
96. Ibid.
97. *New York Times*, "Gen. Jones Dodges the Color Question," February 20, 2013.
98. *New York Times*, "Gen. Rosalie Jones and Her Suffrage Hikers in Washington," February 28, 2013.
99. Cooney, *Winning the Vote*, 192–93.
100. *New York Times*, "5000 Women March Beset by Crowds," March 4, 1913.
101. *New York Times*, "Gen. Rosalie Jones Flies for Suffrage," May 31, 1913.

Chapter 7

102. Kearns, family history related e-mail correspondence with author.
103. Wheeler, *One Woman, One Vote*, 11.
104. The August 12, 1912 *New York Suffrage Newsletter* (vol. 8, no. 8, pages 117–34) has the full story of the Long Island Whirlwind Campaign.
105. Ibid., 119.
106. *New York Times*, "Suffragists Out for a Stir," July 1, 1913.
107. To see the full story of Serena's fairy tale, go to www.suffragewagon.org and search for the term "Serena."
108. *Brooklyn Daily Eagle*, "Will Movie 'Suffs' Burn Houses? Not if Mrs. Kearns Knows It!" August 25, 1915.
109. Edna Kearns, "Votes for Women—the Long Island Movement," *Brooklyn Daily Eagle*, October 11, 1912.
110. See Kearns's comments on the image of the article at the Suffrage Wagon website.

CHAPTER 8

111. *New York Times*, "Why One Woman Wants the Suffrage," November 9, 1912.

112. *New York Times*, "Woman Pleading at Albany," June 1, 1894.

113. Anthony and Harper, *History of Woman Suffrage*, 12,751.

114. Harriet Burton Laidlaw, *NAW*, 2:358.

115. AAUW, Early College Women, www.northnet.org.

116. Anthony and Harper, *History of Woman Suffrage*, 14,263.

117. Van Voris, *Carrie Chapman Catt*, 118.

118. Kent, *Discovering Sands Point*, 104.

119. See Laidlaw, *Organizing to Win*.

120. Rhoda Amon, "Heirloom Banner Given to LI Women: Remembers Mama as Suffragist," *Long Island Press*, October 26, 1964.

121. *New York Times*, "Women will Unveil Honor Roll Tablets," March 26, 1931. The names of the other Long Islanders were Irene Corwin Davison, Grace E. Clapp Greene, Helen Sherman Pratt, Katrina Ely Tiffany and James Lees Laidlaw, all of whom were listed on the National Honor Roll.

122. Amon, "Heirloom Banner."

CHAPTER 9

123. *New York Times*, "William A. Duer Dies at the Mackay Home," October 28, 1905.

124. MacKay, Baker and Traynor, *Long Island Country Houses*, 292.

125. *New York Times*, "Mrs. Mackay Elected School Trustee Easily," August 3, 1905.

126. Mackay, "President's Address."

127. Mabel Potter Daggett, "Suffrage Enters the Drawing Room," *Delineator*, January 1910.

128. *New York Times*, "Mrs. Mackay Quits as Suffrage Head," April 15, 1911.

129. [Atlanta, Georgia] *Constitution*, "Equal Franchise Society Discussed by Mrs. Mackay," October 17, 1909.

130. *New York Times*, "Harvey Scoffs at Anti-Suffragists," August 13, 1911.

131. Mackay, "Interview with Mrs. Clarence Mackay," 32.

CHAPTER 10

132. Sagamore Hill is now a national park and a national historic site. For more information, see www.nps.gov.
133. Gable, interview on *American Experience*.
134. Bishop, *Theodore Roosevelt and His Time*, 127.
135. Caroli, *Roosevelt Women*, 122.
136. Naylor, "To the Manor Born," 32.
137. Caroli, *Roosevelt Women*, 326.
138. Wagenknecht, *Seven Worlds of Theodore Roosevelt*, 89.
139. See the Theodore Roosevelt Association website.
140. Ibid.
141. *Woman's Journal*, "Colonel Roosevelt Sends Message," November 6, 1915, 357.
142. *Suffolk County News*, "Suffrage at Oyster Bay," September 14, 1917.
143. Morris, *Colonel Roosevelt*, 237.

CHAPTER 11

144. The entire story is detailed in Sammis, "Women Members of the State Assembly."
145. *Long Islander*, "Born of Early 'Drys,'" February 21, 1919.
146. *Long Islander*, "First Woman Legislator," November 8, 1918.
147. *Long Islander*, "Women in Earnest," November 3, 1911.
148. *Long Islander*, "Notes," June 7, 1912.
149. Fowler, "Carrie Chapman Catt, Strategist," 303.
150. Ibid., 301.
151. Van Voris, *Carrie Chapman Catt*, 118.
152. *Long Islander*, "Women Vote in Washington, Oregon, California, Idaho, Nevada, Arizona, Montana, Utah, Wyoming, Colorado, Kansas, and Illinois. Why Not New York?" March 12, 1915.
153. Matthews, "Woman Suffrage Movement," 66.
154. *New York Times*, "Vote on the Suffrage Amendment," November 3, 1915.
155. *New York Times*, "Suffrage Fight Won in Cities," November 15, 1917.
156. Flanagan, "First Woman of the House," 3.
157. New York State Legislative Record, Ida Bunce Sammis.
158. Sammis, "Women Members of the State Assembly."

CHAPTER 12

159. Wyman, *Autobiography of Elizabeth Oakes Smith*, 14.
160. Ibid., 43.
161. Garrity, *ANB*, 167.
162. Elizabeth Oakes Smith, *NAW*, 3:309.
163. Wyman, *Autobiography of Elizabeth Oakes Smith*, 73.
164. Smith, *Sinless Child*, 18.
165. Smith, "Woman and Her Needs," 11, 21–22.
166. Smith, "Address at National Woman's Rights Convention."
167. Smith, "Woman and Her Needs," 1, 4.
168. Ibid., 4.

CHAPTER 13

169. See the Booth Family of Long Island genealogy website.
170. Naylor, "In Deeds of Daring Rectitude," 38.
171. *Suffolk County News (Sayville)*, "Suffrage Speakers Mrs. Kearns and Miss Davison in Columbia Hall Monday," April 2, 1915.
172. *New York Times*, "Suffrage Aerial Party," September 1, 1913.
173. Terborg-Penn, *African-American Women*, 95.
174. Garnet, *NBAW*, 388.
175. Spinzia, "Women of Long Island: Clare Booth Luce," 3.
176. *Brooklyn Daily Eagle*, "Women's Work Nearly Over," September 30, 1898.
177. *East Hampton Star*, "Open Air Suffrage Meeting," August 22, 1913.
178. *New York Times*, "Suffragists a Baby Over," September 19, 1913. The article also reported that an anti-suffragist left her baby at the tent and did not return for him until the next day. Apparently, the mother thought the father had the baby, and the father thought the mother had him. The story notes that they were so grateful that the suffragists had cared for him so well that they converted to the suffrage cause.
179. Severance, *Cornelia Bryce Pinchot*, 31.
180. *New York Times*, "Mrs. H.L. Pratt Dead at Home Here," January 3, 1935.
181. *New York Times*, "Off for Suffrage Meeting," December 9, 1917.
182. Spinzia and Spinzia, *Long Island's Prominent North Shore Families*, 626.

183. Coles, *History of Glen Cove*, 68.

184. Katrina Ely Tiffany, *DAB*, 18:534.

185. *East Hampton Star*, "Open Air Suffrage Meeting," August 22, 1913.

186. *New York Times*, "Off for Suffrage Meeting," December 9, 1917.

187. *Hampton Chronicle News*, "Valiant Battle for the Right to Vote," May 17, 1990.

BIBLIOGRAPHY

American Association of University Women. "Early College Women: Determined to be Educated." www.northnet.org.

Anthony, Susan B., and Ida Husted Harper, eds. *The History of Woman Suffrage in Six Volumes.* Vol. 4. West Roxbury, MA: B&R Samizdat Express, digital version, 2012.

Belcourt Castle. www.belcourtcastle.com.

Belmont, Mrs. Oliver H.P. "Woman's Right to Govern Herself." *North American Review* 190 (November 1909): 664–68.

Bishop, Joseph Bucklin. *Theodore Roosevelt and His Time.* New York: Charles Scribner's Sons, 1920.

Bland, Sidney R. "Never Quite as Committed as We'd Like: The Suffrage Militancy of Lucy Burns." *Journal of Long Island History* 17, no. 2 (1981): 4–23.

Blatch, Harriot Stanton, and Alma Lutz. *Challenging Years: The Memoirs of Harriot Stanton Blatch.* New York: G.P. Putnam and Sons, 1940.

Booth Family of Long Island. http://longislandgenealogy.com/Surname_Pages/booth.htm.

Brooklyn, New York. www.brooklyn-usa.org.

Brown, Hallie Q. *Homespun Heroines & Other Women of Distinction.* New York: Oxford University Press, 1988.

Burke, John A., and Andrea Meyer. "Spies of the Revolution." *NY Archives Magazine* (Fall 2009): 9.

Burns, Ken, and Geoffrey C. Ward. *Not for Ourselves Alone: The Story of Elizabeth Cady Stanton and Susan B. Anthony.* New York: Alfred A. Knopf, 1999.

Caroli, Betty Boyd. *The Roosevelt Women.* New York: Basic Books, 1998.

Cash, Floris. "Gender and Raced Consciousness." *Long Island Women.* Edited by Natalie Naylor and Maureen O. Murphy. New York: Heart of the Lakes Publishing, 134.

Catt, Carrie Chapman et al. *Katrina Ely Tiffany.* New Haven, CT: Yale University Press, 1929.

Coles, Robert R. *History of Glen Cove.* Glen Cove, NY: privately published, 1968.

Cooney, Robert P.J., Jr., in collaboration with the National Woman's History Project. *Winning the Vote: The Triumph of the American Woman Suffrage Movement.* Santa Cruz, CA: American Graphic Press, 2005.

Daggett, Mabel Potter. "Suffrage Enters the Drawing Room." *The Delineator,* January 1910.

Dalton, Kathleen. *Theodore Roosevelt: A Strenuous Life.* New York: Knopf, Borzoi Books with Random House, 2002.

Dannett, Sylvia, ed. *Profiles of Negro Womanhood.* New York: Educational Heritage Inc., 1964.

DeRiggie, Millie. "The Wright Sisters." *Long Island Women.* Edited by Natalie Naylor and Maureen O. Murphy. New York: Heart of the Lakes Publishing, 21.

DeWan, George. "Long Island Our Past." *Newsday,* December 15, 1998, A42.

Dictionary of American Biography. New York: Charles Scribner's Sons, 1928–36.

Dublin, Thomas, and Margaret Johnston. "How Did Elisabeth Freeman's Publicity Skills Promote Woman Suffrage, Anti-Lynching and the Peace Movement, 1909–1919?" Woman and Social Movements in the U.S. (for-fee educational database for universities/libraries).

Dubois, Ellen Carol. *Harriot Stanton Blatch and the Winning of Woman Suffrage.* New Haven, CT: Yale University Press, 1997.

Flanagan, John J., Assemblyman. "First Woman of the House." New York: privately published, 1984.

Fowler, Robert Booth. "Carrie Chapman Catt, Strategist." *One Woman One Vote.* Edited by Marjorie Spruill Wheeler. Oregon: New Sage Press, 303.

Freeman, Elisabeth. "Why I Am a Militant Suffragette." *Woman's Journal* (1914).

Gable, John, and the Theodore Roosevelt Association. Interview on *American Experience.* PBS. www.pbs.org/wgbh/americanexperience/features/interview/tr-gable.

Garrity, John A., and Mark Carnes, eds. *American National Biography.* New York: Oxford University Press, 1999.

Gurko, Miriam. *The Ladies of Seneca Falls: The Birth of the Woman's Rights Movement.* New York: Schocken Books, 1976.

Harriet Quimby. www.harrietquimby.org.

Havemeyer, Louisine. "Prison Special: Memoirs of a Militant." *Scribner's Magazine* 71 (June 1922): 661–76.

———. "The Suffrage Torch: Memoirs of a Militant." *Scribner's Magazine* 71 (May 1922): 528–38.

Havemeyer, Louisine, and Susan Alyson Stein, eds. *Sixteen to Sixty: Memoirs of a Collector*. Stein, NY: Ursus Press, 1961.

Hofstra University. www.hofstra.edu.

Horton, H.P. "America's First Woman Patentee." *Long Island Forum* (January 1945).

An Interactive Scrapbook of Elisabeth Freeman, Suffragette, Civil Rights Worker and Militant Pacifist. www.elizabethfreeman.org.

Irwin, Inez Haynes. *The Story of Alice Paul and the National Women's Party*. Fairfax, VA: Denlingers Publishers, 1964.

James, Edward T., Janet Wilson James and Paul S. Boyer, eds. *Notable American Women: A Biographical Dictionary*. 3 vols. Cambridge, MA: Belknap Press of Harvard University Press, 1971.

Jones, Mary J. Gardiner. *Tearing Down Walls: A Woman's Triumph*. Lanham, MD: Hamilton Books, 2008.

Kearns, Marguerite. Comments on the article "Suffragists and Police in Fierce Fight." Suffrage Wagon website. http://www.oldsite.suffragewagon.org/1919newsclip.jpg.

———. Family history related in e-mail correspondence to author.

Kent, Joan Gay. *Discovering Sands Point: Its History, Its People, Its Places*. New York: Village of Sands Point, 2000.

LaGumina, Salvatore J. *From Steerage to Suburb: Long Island Italians*. New York: Center for Migration Studies, 1988.

Laidlaw, Harriet Burton. *Organizing to Win: A Handbook for Working Suffragists*. New York: NAWSA, 1914.

Leoniak, Mallory, B.A. Gombieski and Jane Gombieski. *To Get the Vote: Woman Suffrage Leaders in Suffolk County*. Brookhaven, NY: Town of Brookhaven Publisher, 1992.

Lunardini, Christine. *From Equal Suffrage to Equal Rights: Alice Paul and the National Woman's Party, 1910–1928*. New York: toExcel, 1986.

Mackay, Katherine. "An Interview with Mrs. Clarence Mackay on Woman Suffrage." *Munsey's Magazine* 41 (1909): 32.

———. "President's Address at the Annual Meeting of the Equal Franchise Society." Published by the Equal Franchise Society for its members in 1909. Private collection.

MacKay, Robert, Anthony Baker and Carol A. Traynor, eds. *Long Island Country Houses and Their Architects, 1860–1940.* New York: SPLIA, with W.W. Norton, 1997.

Mary Cassatt. www.marycassatt.org.

Mary J. Gardiner Jones. www.marygjones.com.

Matthews, Jane J. "The Woman Suffrage Movement in Suffolk County, New York: 1911–1917: A Case Study of the Tactical Differences Between Two Prominent Long Island Suffragists: Mrs. Ida Bunce Sammis and Miss Rosalie Jones." Master's thesis, Hofstra University, 1988.

Morris, Edmund. *Colonel Roosevelt.* New York: Random House, 2010.

Morris, Sylvia Jukes. *Edith Kermit Roosevelt: Portrait of a First Lady.* New York: Coward, McCann & Geoghegan Inc., 1980.

National Park Service. "Seneca Falls." www.nps.gov/wori/historyculture/seneca-falls-in-1848.htm.

Naylor, Natalie. "In Deeds of Daring Rectitude: Winning Votes for Women in Nassau County and the Nation." *NCHSJ* 50 (1995) 38

———. "To the Manor Born: Theodore Roosevelt, Country Gentleman, and Edith Kermit Roosevelt, the Lady of Sagamore Hill." *NCHSJ* 65 (2010): 32.

———. *Women in Long Island's Past: A History of Eminent Ladies and Everyday Lives.* Charleston, SC: The History Press, 2012.

Naylor, Natalie, and Maureen O. Murphy, eds. *Long Island Women: Activists and Innovators.* New York: Heart of the Lakes Publishing. 1998.

New York Suffrage Newsletter. New York: New York State Woman Suffrage Association, 1912.

Paul, Alice. "Conversations with Alice Paul, Woman Suffrage and the Equal Rights Amendment." Conducted by Amelia R. Fry, University of California, 1976. www.content.cdlib.org.

Salvation Army. www.salvationarmy.org.

Sammis, Ida Bunce. New York State Legislative Record, 1919. New York: State of New York.

———. "Women Members of the State Assembly." *State Service Magazine* 4 (March 1920).

Severance, Carol. *Cornelia Bryce Pinchot.* Milford, PA: Grey Towers National Historic Landmark Publication, n.d.

Sewall-Belmont House and Museum. www.sewallbelmont.org/womenwecelebrlate/alva-belmont.

Sherr, Lynn. *Failure Is Impossible: Susan B. Anthony in Her Own Words.* New York: Times Books–Random House, 1995.

Sicherman, Barbara, and Carol Hurd Green, eds. *Notable American Women: The Modern Period*. Cambridge, MA: Belknap Press of Harvard University Press, 1980.

Smith, Elizabeth Oakes. "Address at National Woman's Rights Convention, 09/08/1852." Women and Social Movements in U.S. (for-fee educational database for students/faculty of the University of New York).

———. *The Sinless Child & Other Poems by Elizabeth Oakes Smith*. Edited by John Keese. New York: Wiley & W.D. Ticknor, 1823.

———. "Woman and Her Needs." *New York Tribune*, 1851. www.neiu. edu/~thscherm/eos/w&n.htm.

Smith, Jessie Carney, ed. *Notable Black American Women*. Detroit, MI: Gale Research Inc., 1992.

Spinzia, Judith. "Women of Long Island: Clare Booth Luce (1903–1987), the Long Island Connection." *Oyster Bay Historical Society's Freeholder* (Summer 2009): 3–19.

———. "Women of Long Island: Mary Elizabeth Jones, Rosalie Gardiner Jones." *Oyster Bay Historical Society's Freeholder* 11 (Spring 2007): 3–7.

Spinzia, Raymond. "In Her Wake: The Story of Alva Smith Vanderbilt Belmont." *Long Island Historical Journal* 6 (Fall 1993): 96–105.

Spinzia, Raymond, and Judith A. Spinzia. *Long Island's Prominent North Shore Families, Their Estates and Their Country Homes*. College Station, TX: Virtual Bookworm, 2006.

Stasz, Clarice. *The Vanderbilt Women: Dynasty of Wealth, Glamour and Tragedy*. New York: St. Martin's Press, 1991.

Stevens, Doris. *Jailed for Freedom: American Women Win the Vote*. Edited by Carol O'Hare. Troutdale, OR: New Sage Press, 1995. Originally published in 1920.

St. Johnland Nursing Center. http://www.stjohnland.org/history.php.

Stuart, Amanda Mackenzie. *Consuelo and Alva Vanderbilt: The Story of a Mother and Daughter in the Gilded Age*. United Kingdom: HarperCollins, 2005.

Suffrage Wagon News Channel. http://www.suffragewagon.org.

Terborg-Penn, Rosalyn. *African-American Women in the Struggle for the Vote, 1850–1920*. Bloomington: Indiana University Press, 1998.

Theodore Roosevelt Association. www.theodoreroosevelt.org.

University of Virginia Historical Census Browser. www.mapserver.lib. virginia.edu.

U.S. Congress. *Congressional Record*. 65th Cong., 2d sess., 1918, 1919. Washington, D.C.: U.S. Printing Office.

Van Voris, Jacqueline. *Carrie Chapman Catt: A Public Life*. New York: Feminist Press, City University of New York, 1987.

Von Drehle, David. *Triangle: The Fire that Changed America.* New York: Atlantic Monthly Press, 2003.

Wagenknecht, Edward. *The Seven Worlds of Theodore Roosevelt.* New York: Longmans, Green & Company, 1958.

Wheeler, Marjorie Spruill, ed. *One Woman One Vote: Rediscovering the Woman Suffrage Movement.* Troutdale, OR: NewSage Press, 1995.

Woman Suffrage Memorabilia. www.womansuffragememorabilia.com.

Wyman, Mary Alice, ed. *Autobiography of Elizabeth Oakes Smith.* Lewiston ME: Lewiston Journal Company, 1924.

INDEX

INDEX

ABOUT THE AUTHOR

Antonia Petrash was born in New York City; her family later moved to Plainview, Long Island, where she was raised and attended school. Soon after her marriage, she and her husband moved to the city of Glen Cove, where they founded with her husband's mother and sister a family business, a German-style delicatessen, which they operated successfully for twenty-five years.

After selling the business in 1988, Antonia finished her undergraduate degree at New York State's Empire State College and began working in the Glen Cove Public Library as a publicist and program coordinator. She received her master's degree in library and informational science from the Palmer School of Library Science at Long Island University in 1998 and became director of the Glen Cove Public Library in 2006.

Writing has always been an avocation, and in 1999, she combined her abiding interest in women's history with her love of writing, becoming the author of *More than Petticoats: Remarkable New York Women*. In 2001, she followed this with *More than Petticoats: Remarkable Connecticut Women*.

She recently retired and still lives with her husband and family in Glen Cove.

Visit us at
www.historypress.net

This title is also available as an e-book.